770.
22

D1391944

EAMONN McCABE
Photographer

EAMONN McCABE
Photographer

with text by
SIMON BARNES

and with a foreword by
EDWARD LUCIE-SMITH

THE KINGSWOOD PRESS

The Kingswood Press
an imprint of William Heinemann Ltd,
10 Upper Grosvenor Street, London W1X 9PA
LONDON MELBOURNE
JOHANNESBURG AUCKLAND

Photographs © Eamonn McCabe 1987
Foreword © Edward Lucie-Smith
Text © Simon Barnes

First published 1987
0 434 98110 9

Typeset by Rowland Phototypesetting Ltd,
Bury St Edmunds, Suffolk
Printed and bound in Great Britain by
Butler & Tanner Ltd, Frome and London

For Peter Corrigan, Sports Editor of *The Observer*,
with apologies for the lack of any photographs of horses laughing!

Acknowledgements

I want to thank everyone at *The Kingswood Press* and *The Observer* for their help and support and for believing in my new work. Also Dave Hendley for printing all the photographs in the book and for his great encouragement. I am also indebted to Simon Barnes for turning my jumbled thoughts into a most readable text.

CONTENTS

Foreword by Edward Lucie-Smith ix

Text by Simon Barnes xi

Sporting photographs 1

Landscapes 53

Notes to photographs 83

FOREWORD

It must be said at once that I am not a sports buff but an art buff and what caught my attention, some time back, when I flipped casually through the sports pages of *The Observer*, was the quality of Eamonn McCabe's images as aesthetic objects. Whatever the sport depicted, the pictures had wonderful visual élan, spiked, as Simon Barnes suggests in his introductory essay, with an unmistakable and delicious sense of humour.

Just by chance, it happened that I was in a position to do something practical about the admiration with which these images inspired me. I was in the process of preparing one of the three Peter Moores' projects which I selected for the Walker Art Gallery, Liverpool. The essence of these exhibitions was that they should bring together a wide variety of different kinds of contemporary art, and that they should give each individual artist enough elbow-room to express himself fully. The roster of artists who participated in the three successive exhibitions I curated is very impressive – they included Henry Moore, Bridget Riley, Michael Andrews, Tom Phillips and John Bellany. There were also new artists who were to go on to make major reputations – one was Christopher Le Brun, now considered one of the most exciting of younger British painters.

I think Eamonn was distinctly startled and perhaps a little suspicious when asked to exhibit his work in this context. Did I intend to send him up? But he was, inevitably, a triumphant success, and I think the invitation was not only one of the shrewdest choices I ever made, but had a moral point – it demonstrated that something of high aesthetic value could effortlessly reach out and communicate with a popular audience, even with an audience which had no notion that it was being offered art.

The beautiful new landscape photographs included in this book, with their impeccable feeling for the arrangement of shapes, demonstrate that it is not the subject matter but the artist's talent which is the primary thing – in photography just as much as it is in painting or sculpture. If we go from one extreme to the other – from the unpeopled landscapes to the terrifying picture of the Heysel Stadium disaster just beginning to occur – we find the same very personal sense of pictorial rhythm. Paradoxically, it is this quality, abstract when reduced to its essence, which makes Eamonn McCabe one of the great communicators in contemporary photography.

Edward Lucie-Smith
November, 1986.

ix

TEXT BY SIMON BARNES

Sports journalists – writers and photographers both – rather pride themselves on their lack of imagination. They boast about a kind of boot-faced professionalism: an ability to supply the required commodity absolutely on time. From such people you get your eight paragraphs bang on the final whistle, along with your perfectly sharp photograph of the goal-scorer. Who could ask for anything more than that? Few sports editors do.

On the other hand, perhaps the actual readers could want a little more. Sports journalists tend to get submerged by their own deadlines, and by their subject: nothing but sport and the recording of sport seems to matter after ten years of covering football matches every Saturday. No unsporting thoughts ever enter the heads of such professionals, you would think from their work. It is more than their jobs are worth, for a start. Back at the office, the men who judge the material produced are equally slaves to the 'news value' of events, to facts, to the entire myopic philosophy of boot-faced professionalism.

Sports journalists are not required to go beyond the recording of the day-to-day trivia of sporting life. If you are a photographer, you must just get stuck in with your ultra-long lenses and your motor-drives and come back with a hard, sharp picture of Ian Botham. It is perfectly possible for a photographer to do more: the best can use their craft to convey the pleasures and pains of sport. Dr Johnson once said that the point of art was to teach us how better to enjoy life, or how better to endure it. But on the whole, it is better not to use the term 'art' to people in newspapers. They tend to shy away from it like frightened racehorses. The point here is that sports journalism tends not to go beyond the ordinary because of a kind of conspiracy of ordinariness between its practitioners.

Eamonn McCabe is one of the photographers to have cracked this conspiracy. He has worked for ten years at *The Observer*, taking the kind of sports pictures that would have given a fit of the horrors to a man too much a slave to news values: but in an immensely fruitful association much of his finest work has been used bravely, boldly, imaginatively and memorably. They don't insist on a picture of the winning goal: they will use a picture of the man who came 71st if it is a picture that means something. A touch of art has infiltrated sports journalism: frightening thought.

McCabe's approach has never been mechanical, never in the slightest way boot-faced: he is an emotional photographer, who needs a strong one-way involvement with his subject. There

was a recent period in which he was beginning to feel rather restless about it all: he began to wonder if he hadn't, perhaps, already taken all the Eamonn McCabe shots possible. If he wasn't beginning to repeat himself.

But then came a flash of rejuvenation. It happened in, of all places, Las Vegas. His entire photographic approach changed forever in the course of a two hour stroll around town. There was a new kind of picture to take. More of that later: this, plus a spell away from *The Observer*, a kind of accidental sabbatical, rekindled his enthusiasm. Let us first consider the memorable work McCabe has done as a sports photographer with his armoury of motorised telephotos. It goes a long way beyond the recording of the news. And after his 10 years in the front line, it is time to bring together the best 50 shots or so: pictures that say more about sport (or if you like, life) than a million photographs of the winning goal.

People in sports journalism talk about 'an Eamonn McCabe shot' even when McCabe did not take the picture. They are talking about a style, a vision, a way of looking at sport. Take the picture of the boxer's hands on the cover. If you wrote 'Eamonn McCabe' over it in letters of fire, it would not make its provenance more obvious. No one else would have bothered to take the photograph; or even if he had, he would not have got it quite like that.

'I've always loved boxing gyms. I love the atmosphere, the smells, the tough, working class edge,' McCabe said. 'It always feels like real life there. I was at Frank Warren's gym at King's Cross, to take pictures of another boxer, when I took this one. I noticed this fellow, Sylvester Mittee, standing by a window, taping his hands up. If he'd been one of the top boxers at the gym, he'd have had some gopher doing it for him. He was by the window, and with the sun pouring in, and with the black skin and the white tape and the sunlight, I saw a picture immediately. The thing

was to decide whether I wanted the head, or the body, or just the hands. I used a long lens and went for the hands. It's something I'm really pleased with: this lovely quiet moment. It's not set up: hardly any of my work is set up. I didn't get the guy to do it four or five times. He was just getting on with it by himself.'

McCabe likes to stand well away from his subjects, and to use a lens that looks like a bazooka. He wants to be invisible: a fly on the wall with a motor-drive buzzing like fury and never missing a trick. He took the boxer with a 180mm lens, long enough to take a footballer on the edge of the box. The lens gave him the distance he wanted to preserve his one-way involvement with the subject, and, because of the shallow depth of focus on any long lens, the hands are sharp but the breast-bone is soft: gently suggested rather than obtrusively and distractingly insisted on. The subject fills the frame, the background is minimised: this is typical of McCabe's style.

The picture is helped by some brilliant work in the dark-room: McCabe used the word himself. After all, he didn't print it. 'I can print, I quite like doing it, but great printers get more out of a negative than I can. I've never been a technician in my life; I'm far more an emotional than a technical photographer. I've never even been properly trained. I came in off the street, more or less, and did things because they excited me. I'm not the sort that can stay in the dark-room for five hours to get a print absolutely right. I always want to whip a picture out and have a look at it. When I develop a film, I'm always snatching it out to see what I've got on the negatives. I have brown stains on all my shirts because of it.'

Time and again, McCabe sees a picture that no one else does. Sometimes the result is serious and insightful, like the boxer's hands. At other times it is pure slapstick. Take the bald goalkeeper (page 36). This came from an ordinary, rather dull game: Fisher Athletic v Bristol City in an

early round of the FA Cup. The picture is a real treat. The bald head, the shining white football: the man looks as if he is about to punt his own head over the halfway line.

McCabe had been sent to cover the match: every year sports photographers cover such matches in the hope of picking a 'giant-killing': events that always seem to happen at the ground where your top photographer isn't. It worked out that way for McCabe at Fisher Athletic. 'It was an abysmal day, very dark, poor floodlights. But as soon as John Shaw, the Bristol City goal-keeper came out, I said to myself, that guy is going to make a picture sooner or later. So I got behind his goal. It was the end the non-League boys were attacking, so I was covered if anything sensational happened. But it didn't, so I just sat there working on the goalie; I knew that sooner or later he would be diving after his own head, or something.

'In the end, it was a punt out of goal that made the picture. There I was, working like mad with a long lens on all the punt-outs. You'd never take a picture like that normally, not unless you wanted a super-safe frame of Pat Jennings, or someone. None of the other photographers around me could see what I was working on. It's funny: you can have all the elements there, yet some people will see different things. Actually, the picture caused a bit of a stir at the time. Some people loved it, but others thought I was being cruel to bald people. I saw it as a very gentle sort of piss-take, myself, but one or two people were upset.'

Your hard news man, your news slave, would not have noticed him or commented on him. But any spectator would. Spectators, like newspaper readers, are not indissolubly wedded to news values. A spectator would have gone home saying: 'Did you see the Bristol goalie? I thought he was going to kick his own head into the centre circle.' One of McCabe's many strengths as a sports photographer has always been the ability, like a spectator, to be entertained by the events he

has covered: not taken in by sport's monstrous self-importance. Many newspaper sports desks are fully committed to this, but McCabe, because he worked with such sympathetic people as Geoffrey Nicholson and Peter Corrigan for so long, was able to take such delightful pictures and, what is more, to get them used well. 'I feel sorry for the boys from some of the papers,' McCabe said. 'They have got to get the news picture, and that's it. If a dog pees against the goalpost, they've got to get the shot. And if the dog isn't smiling, they're in trouble.'

These two pictures, the boxer's hands and the bald goalie, show the two strongest areas of McCabe's work: formal shape and a whimsical sense of humour. The humour is never cruel (unless you are hypersensitive on the subject of bald goalkeepers); McCabe has even taken a gently amusing picture of a Down's Syndrome runner, at a games for the mentally handicapped at Crystal Palace. The picture is nothing less than admiring: 'I love the effort,' he said. McCabe really likes and is really interested in sportsmen, you see, something that is by no means shared by all sports journalists. He is on their side even when he is smiling at them. And patterns: Anthony Burgess wrote in *Earthly Powers*: '(James) Joyce had an empty Sweet Afton packet in his hand, the cigarettes themselves lying on the ground virginal and wasted in a sort of quincunx pattern. Things tended to form into patterns for Joyce.' In the same way, sportsmen tend to form into patterns and shapes for McCabe: he looks for pattern, sees it, and reaches out with his long lenses to grab it. Both the boxer's hands and the bald goalie are very much created pictures: not set up, or posed, but created in McCabe's mind and then, as it were, burgled from the passing scene.

But McCabe's sports pictures are all taken for a newspaper: for public, not private pleasure. Newspaper work is a constant battle against time and event. It is no good having a beautiful picture full of whimsical humour if it is ten minutes late,

not if you are working for a newspaper. Indeed the pressure of the successive deadlines for a Sunday paper that occur as each edition goes to bed throughout Saturday afternoon means that a sports photographer must have a usable picture for the first and furthest-flung edition by ten past three. After ten minutes of a football match, a Sunday paper sports photographer must hand his film over to a waiting messenger. 'I'm sure that when I win awards, there are people in the north of Scotland who say they've never known me take a decent photograph in my life,' McCabe said. 'But that's newspapers.'

And while decrying the tyranny of news values – McCabe has had people say: 'We can't use this brilliant picture of that man getting tackled, because he was on the winning side. We could only have used it if he had lost' – McCabe has known iard news photog that could be run. oalkeepers are an photogra- pher m can use his talents ore under- standab he must, above a

McCabe's record of getting the picture for the major and unexpected event is impressive. Indeed, there are moods in which he will pride himself more on the big story pictures than on his genuinely innovative photography. He takes his own vision, his ability to take 'Eamonn McCabe shots' for granted. After all, it is innate. The skill of getting a major news shot has been acquired: a matter of good timing, good luck, and good professional habits.

He was, for example, the only working photographer to get a picture of Cambridge sinking in the Boat Race in 1978. On another occasion, he had a remote control camera in the back of the net when Norman Whiteside scored the 89th minute winner in the 1985 Cup Final. In fact, McCabe was packing up his gear at the time, and had the foot-pedal shutter-release in his hand instead of beneath his foot. He smacked the pedal down optimistically, got the timing perfect, and the picture was used the following day over six columns. That, in newspaper terms, means pretty enormous, which is how photographers like their pictures used.

At the 1979 Grand National, he acted like the classic boot-faced hard news man. Alverton, the mount of Jonjo O'Neill, fell at Becher's and did not get up. Screens were swiftly erected around the horse, which was destroyed there and then, with O'Neill weeping alongside. McCabe brutally pushed his way past the screens and took pictures. 'It was as if I'd become a different guy,' he said. The picture, though, is not exactly insensitive: in fact it is heart-rending. It is a sad picture, and it was worth taking.

That one is not in this book. But what is, perhaps, the most important hard news sports picture ever taken is included. It is on page 50, and it is horrifying. It was taken at Heysel Stadium, Brussels, at the European Cup Final in 1985. It is a photograph of a nightmare.

McCabe was at the other end of the stadium when the first stirrings of trouble began. 'I was looking the length of the pitch at the sea of red for Liverpool, and suddenly the sea of red began to move. I just thought then, here we go again. It happens at every big match. I thought I ought to take a picture. It is news photography, not sport, but I thought I'd better get down to the other end. I thought that someone might get hurt. I had my football lenses mounted on the cameras, the 180 and the 400. I rushed round the track on the outside, and I decided to get to the goal and start shooting. But as I got there, the wall was beginning to break. The long lenses were no good to me here. But in my breast pocket, I had a little Nikon autofocus camera. I had brought it with me for snatching shots of the presentation. It is no more than a superior snapshot camera, but for occasions like a presentation, it is useful. Luckily

I had it all ready and loaded. I took it from my pocket and took two frames. That was it. I know the picture looks as if I had been working on it for ten minutes, but it wasn't like that. One second after taking it, I was pushed away, and there were soldiers everywhere. And still no one realised how serious it was.

'I won an award with that picture, and it went all over the world as a news picture at the time. I'm still not happy about it. It is, if you like, the tacky end of the job. That's all; I was there and doing my job. Not something I'm that pleased about. In fact, I didn't really want the picture to do well.' (It was *The Observer* that sold the picture round the world, and the award was unsolicited.) 'I also had second and third thoughts about whether to include it in this book, but in the end, I decided I should. All things considered, it is an important photograph.' It is. It doesn't trivialise, or sensationalise, or intrude. It is the single instant, caught for all eternity, in which the horror began. It is, indeed, an important photograph. And incidentally, it was a picture that no-one else got.

McCabe will tell you that he has been 'lucky' with the number of major news photographs he has got. But this is, of course, an example of the Gary Player Law: the more I practice, the luckier I get. There is more than coincidence, and there is more than mere experience, behind McCabe's 'luck'. It is something to do with McCabe's involvement with whatever it is he is photographing. He becomes emotionally bound up in the event, and has an intuitive understanding of what is happening and, crucially, what will happen next. That is why, time and again, pictures happen for him, the timing of the comedy is perfect and the people seem inevitably to form into patterns for him.

Having said, that, one of the recurring themes of McCabe's conversation is the pictures that got away. Photographers, especially sports photographers, suffer from this disease of perpetual frustration even more than fishermen. The big one that gets the McCabe lamentations going was Sebastian Coe winning the 1500 metres in Moscow at the 1980 Olympic Games. Others got the picture: Coe with his arms extended, as if he were being crucified, his face a quite extraordinary distorted mask of disbelief. McCabe could have been standing behind the tape snapping away; instead he chose to position himself at the last bend. He missed the finish: 'I just walked away from that picture. I can't believe it, I just walked away from one of the great sports pictures of the decade.'

One of the problems of working for a Sunday paper is that the dailies have the first helping of weekday events. The Sundays still cover them, of course, but must find some fresh way of approaching them. At a midweek football international, you might, say, go for an 'in-depth' piece on Glenn Hoddle. That's easy for the photographer: all he has to do is to watch the boy wonder like a hawk all night, with his motor-drives a-whir. But you cannot always work to a plan: often you must react to the event and then produce a piece. This is fine for the writer, who has a day or so to think it over. Not the photographer: he has to get it right on the night: find a fresh view of an event from which everyone has already seen all the obvious pictures.

So with Coe's race, McCabe decided to walk away from the obvious shot, the finish. He got clever, and decided to stand on the last bend: at the point where the race would actually be won as Coe, or it might have been Ovett, put in the decisive kick. 'So I missed the picture. If I'd got it, it would still have been strong enough to use on Sunday, no problem. But I walked away from it.' Well, lots of other people got it. 'But you like to think you would have taken the definitive one.'

So, as a kind of consolation prize, we have, on (page 28) a middle distance picture from the 1984 Olympics. It shows Ovett on the brink of

collapse, and an uncanny moment as Cram, cool and almost dainty, turns to look at Ovett with an expression of well-bred disdain on his face, while Ovett crashes onto the line. Ovett looks haggard and desperate: a spent force. It's a fine picture: McCabe was in the right place at the right time. It is reassuring to know that he has got it wrong now and again. Less reassuring to know that he still reproaches himself for the shots he has missed.

'You miss pictures every day,' he said. 'You have the wrong lens for the shot, you are reloading. The picture of Lendl and Connors (page 27) was frame 37A of a 36 exposure roll. I'm pleased with it: Connors is patting Lendl on the head with his racket. But if there had been one more frame on the roll, I would have actually got the racket on Lendl's head, and that might have been even better.' However, he has got more right than wrong over ten years, one could say. Things have never quite stopped forming into patterns for him. Take the picture of the 1986 London Marathon (page 44). McCabe had not planned to cover the event. But he had responsibilities to a student photographer, and so he took the lad, and his own cameras, along to the start. One wonders if that delightful group, with the bearded eccentric in the middle, had arranged themselves so engagingly because of some occult influence from the photographer: surely they wouldn't have been standing in such nice patterns for any one else. The picture was taken half an hour before the start, and captures all the home-made quality of the event, with nutty runners from all over the country getting ready for the big day. It is another of McCabe's 'gentle piss-takes', and another pleasing pattern.

'There were two or three other photographers taking pre-race shots,' McCabe said. 'And they just didn't see this. I wanted it all to myself, and yet I wanted to share it with them at the same time. I almost said, come on, look at this. But then you think, if they can't see it they won't enjoy it, even if I point it out to them. I mean, I was really enjoying it. It was a very pleasing day for me. And anyway, perhaps they couldn't have got a picture like that past their picture editors.'

But for McCabe, the runners were a real pleasure. That is the way he likes to work: I came, I saw, I burgled. The pictures are stolen, and the subjects never know how much they have revealed of themselves. This is true of his action shots – 'I'm not the world's greatest peak of the action photographers. I'm not the world's quickest focuser. Throw ten tennis balls up in the air and I might be sharp for three of them. Some photographers would get all ten' – and of his portraits. The best of his portraits are not set up, for he is not happy manipulating models. There is a shyness, or perhaps I mean just a reserve, about him: he wants to observe and click, not to invite a contribution from his subject as a studio portrait photographer does. The two best portraits (pages 12 and 13) in the book were both burgled, and each shows more, than any heavily directed, painstakingly lit, self-consciously participated-in shot ever could.

They show two of the most battered faces in sport: Nikki Lauda and Lester Piggott. The way in which each face has been caught in a cross-light emphasises with almost pedantic clarity the hardships each man's chosen sport has inscribed on his face. Each makes one wonder at the rigours of these men's lives: the hunger for achievement that made each man carry on in spite of the sport's pain. With the Lauda shot, McCabe was under instruction to try and get Lauda and Alain Prost together: the two were that year (1984) jockeying for leadership in the driver's championship. 'But they knew we were all after that, so they kept apart,' McCabe said. 'Sometimes these things can be set up, but that's no good. They always end up with soppy, coy expressions. So I was watching both, and getting what I could. And I'm pleased with this one. I know it's a little gruesome. When Lauda first came back to racing

BOURNE COLLEGE
PHOTOGRAPHIC DEPT.
MARCONI CRES.
GUERNSEY.

after his crash, everyone was trying to get photographs of the scar tissue. I didn't want to do that. But there are ways of taking a photograph of someone. I think this ends up as a sensitive portrait of a brave man who has been through hell. I like the flame-proof hood he has on his head, too. I like the way he looks like an eagle.'

The portrait of Piggott is equally revealing: the picture reeks of the years in which Piggott breakfasted on nothing but a cough and *The Sporting Life.* 'I was lucky with this one. He was doing a television interview, with lights, and I was able to sneak in and get the picture. The cross-lighting that brings out the creases on his face came from their lights. Cheating, really.'

Well, sports photography does not need the ethical constraints of rock-climbing, a sport in which you would hate yourself forever if you hung onto some bolt in the cliff-face. In photography, all that matters is the photograph. True, Henri Cartier-Bresson – 'God forbid that I should mention his work and mine in the same breath,' McCabe said – believed that it was wrong to crop any picture: the entire negative had to be used.

'But you just can't have a perfectionist thing about sports photography,' McCabe said. 'Sometimes you are just glad to have a usable picture, never mind how much cropping it might need.' Take the picture of Ladies Day at Royal Ascot (page 40) which, in fact, has something of a Bressonish feel to it. It needed a crop. 'I had the entire race-track between me and those people,' McCabe said. 'You are not allowed to bring cameras into the Royal Enclosure. In order to get the shot, I needed a 500mm lens, and needed to raise the camera high to get above the running rail. That meant I had too much distracting stuff at the top. So the picture needed a crop. Maybe Bresson would have left the top in – there were three pairs of legs, from the knee down. Maybe if there had been four or five pairs of legs, I would have left them in, maybe if they had made a pattern.' Maybe the extra legs would have been there for Bresson. 'Pictures like this have sometimes depressed me, so far as newspaper work is concerned. You can take a shot that you love, and sometimes back at the office people won't see it. Where's the news value, we want winners, that sort of thing.'

Like all creative relationships, it will be observed that McCabe's relationship with *The Observer* was not without its prickly moments. McCabe's temperament does not always direct him in strict hard news directions. His six months away, his inadvertent sabbatical with *Sportsweek* magazine has been beneficial to both sides.

It has been a long relationship, and one during which McCabe has won many awards for his pictures. At those eternally televised showbiz award ceremonies, I am sure that all of us have always wanted to see a speech of acceptance that goes something like: 'As I accept this award, I would like to say a word about Fred Nerd. Fred Nerd fired me five years ago, and told me I would never be good enough to get another part in movies so long as I lived. So on the happy occasion of my being given this award, I would like to say this: up yours, Fred!'

McCabe has actually had the very rare pleasures of doing this, more or less. He won the sports photographer of the year award in 1984, for the fourth time, incidentally. Most of the pictures in his prize-winning portfolio had been rejected by *The Observer.* Not newsy enough, they said. It gave him great pleasure to point this out, albeit with good humour, in his modest speech of acceptance. 'It has long been a running joke, that whenever the Ob turned down a picture it was certain to win an award,' McCabe said, not wholly seriously.

But it was not really *The Observer* he needed a break from. He needed a break from newspapers. A newspaper's prosaic demands of deadline and subject-matter were beginning to be a frustration

HEREWARD COLLEGE
PHOTOGRAPHY DEPT.
BRAMSTON CRES.
COVENTRY.

and not, as before, a stimulus. He went and sat behind a desk at *Sportsweek* magazine for six months. Many people will be amazed that anyone could find anything at all uncongenial about what they consider to be the best job in the world. How could he turn his back on it? Indeed, how did he get such a wonderful job in the first place?

Well, so far as McCabe was concerned – so far as all McCabe's work is concerned – the obvious was eschewed. He did not take any straightforward and pedestrian route to sports photography; he never did any orthodox apprenticeship. Instead, he chucked in the boring office job in which he had somehow got stuck after leaving school, and went bumming around America instead. He went to San Francisco, which he decided was the greatest city in the world, and stayed there. He started to gate-crash university lectures, and kept himself going by washing up in restaurants. He got interested in film-making, and made a movie in which everything was shot from below knee-height: this was, you must recall tolerantly, the sixties.

He loved America, and might have considered staying there. It would have been possible for him to become an American citizen. But this was the sixties, and to be a young male American citizen was to be eligible for the draft. Like Muhammed Ali, McCabe had nothing against them Viet-Cong. He left San Francisco and went back to England. He found absolutely no opening in movies. In the end, he got a trainee photographer's job: by then, he was rather old for such a job, being 23. But they liked his enthusiasm, and he became an assistant at the photo unit of the Physics Department at Imperial College, London.

He left the job to join a photographic agency, in which he was employed printing up pictures of rock stars. Eventually, he persuaded the boss to allow him to take some pictures as well, and he travelled about photographing rock concerts: the Rolling Stones, The Who, The Beach Boys. Marvellous fun, all of that. But it began to pall when the sixties gave way to the seventies and glamour rock came in. McCabe, a child of the sixties, was overcome by a wave of total indifference. Nothing unexpected happened at concerts any more, he complained. Perhaps he was getting old.

At the same time, McCabe had begun to do some odds and ends of work for a company in the same building, called Sporting Pictures. McCabe has always been a sports nut; to this day, he plays Sunday football. He rather enjoyed the idea of combining sport and photography. Good fun, he thought. He left his pop stars, and took another assistant's job, this time working with Robert Golden, a photo-journalist. Much of the work McCabe had to do involved setting up still-life pictures for book covers. He recalls spending unending hours taking pictures of a globe inside an eggshell for a book called *Small Is Beautiful*. It was all very interesting and very clever, McCabe decided, and definitely not for him.

He was still doing odd sports jobs on Saturday, and decided to expand on that, and move into newspaper photography. He set up the North London Photo Service, which was basically just himself, a telephone and a camera or two. He worked on a local beat of Saracens rugby, Southgate hockey, and Spurs and Arsenal. He sold the stuff to such papers as the *Hornsey Journal*, the *Hampstead and Highgate Express* and the *Islington Gazette*. He took pictures wherever he was asked: he did his porridge all right, with pictures of jumble sales, fetes, the lot. It is a poor newspaper journalist who cannot say he has done all that.

It was the sports side of the business that had the most interesting possibilities. McCabe started to offer pictures of his more fashionable matches to the national papers. National papers cannot always have their own men everywhere they would wish: a good free-lance is an inestimable bonus. *The Guardian* started to use McCabe

more and more: four or five times a week was not unusual. McCabe could claim the status of a national newspaper sports photographer. The rest all followed logically: and the long and rewarding stint with *The Observer* began.

He joined *T* ris Smith had left t gh act to follow: S his innovations ar ls. McCabe, not ut because this w d a style very diff ay from the hard- g alities of Smith's work: the McCabe style is far more emotional. Sport was the ideal subject for McCabe; not just because he loves the stuff, but also because sport itself is so emotional a business. People reveal themselves in sport as they never do in any other public, readily photographable activity: this is why sports photography so often has things you cannot find elsewhere. Sport is exhausting, exhilarating, disastrous, ghastly, the best thing in the world, and the worst. The athletes give themselves away at every turn: McCabe is there, with his long lenses reaching out greedily to steal these moments. There are delightfully comic moments, like the pop-eyed ski-jumper (page 3) or the blazing intensity of Daley Thompson (page 20). His picture of Thompson is not the often twittish figure in victory celebration; it is Thompson at work, burning with determination. McCabe wanted Thompson as the great athletic weapon, cocked but not fired: the intensity comes through in buckets.

Why is the picture so much more intense than most pictures of Thompson in action? It is not, or rather, not only that McCabe went click at exactly the right moment. There is also a technical reason: the background. There is, you will note, no background. The absence of background is crucial. All photographers love to talk technicalities – McCabe less than most, it must be said –

and the technical subject he hammers most is the question of background. 'The background is the most important thing in a good sports picture,' he said, overstating his case like mad. 'You can have the greatest sports action picture in the world, but it can be spoilt by trees coming out of people's heads, messy and distracting crowd scenes, empty terraces, adverts. You must get rid of all this stuff, blur it into nothing.'

To be technical for a brief moment (photographic technicalities seem to be catching) the smaller the aperture you use, the more you will have in focus. With a long lens, on a small aperture, you can focus a couple of feet either side of accurate and still have a perfectly sharp picture. Also your background will tend to be sharper, more obtrusive, more distracting. McCabe prefers to shoot with the largest possible aperture for the conditions, gambling on getting his focusing absolutely spot-on, in the knowledge that every irreverent detail will be out of focus: blurred into nothing. This is, it will be apparent, a technique that requires a good deal of nerve.

'It's a risk, it's quite frightening at first,' he said. 'But you get so much more drama that way. And in terms of focus, when you are shooting sports pictures at the top level, if you're out of focus at all, you tend to be out by a long way – not a foot, but five or six yards. So when most people will shoot on 1/500th at f5.6, I'm at 1/1,000th and f4. The higher shutter speed freezes the action more efficiently, the wider aperture shuts out the background more.'

McCabe also tends to use longer lenses than most photographers for any given event. He likes to get in very close indeed: he is looking for something more than a couple of guys kicking a ball about. 'If you go for something slightly longer than you think, the pictures will immediately be better,' he said. 'If you use a 105 for rugby, use the 180 instead. That also is frightening at first, because the image is so much bigger in the frame. But people tend to shoot too loosely

anyway. When people take shots with their instamatics, there are always two little figures in the middle and a two inch margin all around them. Even at the professional level, people should go in tighter. You have to get over the fear of how big everything looks. Because in the end, you will get a bigger image, which will make a much better print. To shoot with a shorter lens and think, "well, they can always crop it" – that's just a cop-out.'

Photographers love gadgets. There is a great temptation to go equipment crazy. McCabe counsels against this. All sports photographers adore the very latest super-fast lenses, but they are specialist tools, and only really relevant to some one who is trying to compete at the highest level. There are more important things than equipment and gimmicks. There was a time in the seventies when sports photography went gaga over gimmicks. Every colour supplement had sports pictures with the image and the colours all gone crazy as the photographer tromboned a zoom lens at his subject. Other photographers crouched at athletes' feet with fisheye lenses: if you read the caption you might just have been able to work out what it was a photograph of. Blur, it, bend it, make it weird: it was a trend that McCabe didn't go for. There is only one worthwhile gadget, and that is the eye of the photographer.

It will be apparent that McCabe's eye has, over the course of his ten years, often picked on things outside the sports photographer's brief. Several pictures betray a marked movement away from the commonplaces of sport. And then came the day in Las Vegas. McCabe had been sent there to cover a world title fight. 'Vegas was a new place for me. It was very hot, and there was a beautiful clean light. I was fascinated by the place. I went walkabout: I walked around for about two hours with a camera, just a little Leica, in my pocket.'

It was the day on which something that had been building up for months, perhaps for years, came bursting out. McCabe started taking photographs of things he found in the street: shapes, patterns, things that struck a note of incongruity. A couple of chairs, just standing in the street, gave him special pleasure, (page 64) 'male and female chairs,' he said. Just standing by themselves in that belting Las Vegas light: McCabe found the same excitement he had felt for years at Cup Finals and Olympic Games as he took the picture on page 58. Then a headless statue in a fountain. Other subjects, other shapes, other patterns caught his attention. It was an intense, a magical day: a day of inspiration. 'It was the day when it all came singing out,' he said. And then, with a slight air of anti-climax, he went to take pictures of the fight.

'When I got home, I actually went into the dark room and printed them,' he said. 'I spent a couple of days on them, and there were three or four pictures I really liked. Great. But I thought, well, that was just a flash in the pan, really. Just Vegas.

'But then I went to San Francisco to cover the Superbowl. It had always been my dream to cover one of the great American sporting events. Especially a Superbowl: the uniforms, the crunches, all the hype. I went out thinking it was going to be a really fabulous day. But in the end, it was not just the sport that excited me. There was something else as well – the idea of getting out into another American town to do some more street photography. I went out with the Leica again, and I got the picture of the wrapped cars (page 60). And it dawned on me then that this was what I wanted to spend my time doing. I didn't just want to go to the Superbowl any more. I also wanted to walk around town with my Leica.'

It was like a dam bursting.

'As a working sports photographer, I get a kind of thump in the chest when I see a picture: in between seeing the picture and actually getting it, a great thump in the chest. When you get that

thump, you know that this is exactly what you should be doing. Now I find that this also happens when I am taking landscapes, in America, or in Norfolk, or Brighton, or anywhere. I know this new stuff is exactly what I should be doing. I don't suppose they will mean all that much to the other sports photographers. Whether they will ever go down the same road, I don't know. It's a different way of seeing.'

McCabe's sports work contains plenty of clues about the way he was going: retrospectively these are quite clear. The marathon, and the Royal Ascot shot are prime examples. But these pictures do have a certain whimsical quality to them; an unforced charm, a gentle sense of humour. The landscapes are lonely, bleak: at times quite desolate.

'In my early days, if I was taking pictures in the street, I would wait for some one to come into the picture. With the one I took of the walkway in Norfolk (page 58), I waited half an hour to be able to shoot it completely deserted. There were people passing it all the time, and a bunch of kids hanging about, posing, trying to get in the shot. But I wanted the place quite empty. The only people I want in pictures now are the shop-window dummies.'

There is only one of the landscapes that includes a human being (page 72), and it is a shot with some echoes of the charming and whimsical McCabe of the bald goalie. 'I stopped at a road in Norfolk, and saw this camp with the sofa. I suppose some kids had made it. While I was working with it, trying to get a picture, this guy just strolled past. I was praying I would get him in; he was great; he looked as if he was walking away from his home. He's very dapper, a bit like the Beau Brummel character striding past in his top hat in the Ascot photograph.'

But most of his landscape work is much harder, much tougher than this. In his sports pictures, McCabe's involvement with the people in them is one way. This shyness or reserve comes through in the landscapes as loneliness. The pictures taken in Portobello have this quality to a quite haunting degree. Portobello is a sad and seedy seaside resort outside Edinburgh: it caught McCabe's imagination while he was in Edinburgh for the Commonwealth Games in 1986. 'I'm afraid there's not much joy in them. There is often a lot of humour in the sports pictures. I don't want to depress people, but I find beauty in these empty landscapes.'

Emptiness is a new thing for McCabe. His sports style is remarkable for its crowding. He works with his extra long lenses and fills the frame to the point of bursting with faces and action and intensity and humanity. But when it comes to landscapes he uses a Leica with a 35mm lens, and still stands well back from his subjects. He traces this new found spaciousness to his friendship with the landscape photographer, Ray Moore. 'In fact, one or two of the landscapes are very much in his style. The caravan (page 73) is, well, not exactly a crib from Ray Moore, but certainly a homage to him. But take the climbing frame (page 54). When I first began with landscapes, I would crowd in, as I did with my sports pictures. He has encouraged me to stand back, to let the picture breathe, to bring secondary elements into the shot. With the climbing frame, I have brought in the line of light bulbs in the background. I like that. In 20 years time, you won't see lights like that any more.'

Moore stopped McCabe thinking like a sports photographer all the time. McCabe's sports work is characterised by longer lenses, tighter shots, a background that has been virtually eliminated, and a great, warm, inescapable human content. His landscape work has almost reversed these principles.

'It is not all-important to me that these pictures should be on walls, though I'm glad they are in the book. But they are like someone's private writings, very satisfying because of this. Ray Moore called his book *Every So Often*, which is

good. Every so often, a picture turns up. These pictures are just a few days of my life.

'It is not vital that the pictures get seen, get published. But I hope there is something in them I can share. I won't have as big an audience with them, as I have for my sports stuff. Some of them are very personal. And commercially, of course, there is no chance of living off them. I use my eye professionally when I work with *The Observer*, and that is great. The landscapes are what I do on my days off. I'm certainly not in it for the money, any more than Ray Moore – he sold two pictures last year. And his work is brilliant.'

Some of McCabe's landscape work involves simple patterns, not this time of sportsmen like the sprinters in the blocks (page 10), but from chance-found things like the tennis court in the snow (page 59). But other aspects of McCabe's new style are far more bizarre: the bus shelter (page 70) shows that side of things. 'I see what I want in the simplest of forms. When you start taking pictures, everything is very complicated. But you start stripping things away, until you begin to see beauty in minimal ways. The bus shelter, a nice shape, a very enjoyable thing to look at. Before, I would have found the beauty in some old person walking past it. But now I like the thing for it's own sake.

'Not every one sees things like that, though. There are beautiful things, beautiful moments, and people walk straight past them. They just can't see it.' Of course we can't. It is up to McCabe to isolate the moment for us. That is his point, as a photographer. Or, if you prefer, as an artist.

Most people in journalism, especially sports journalism, are almost aggressively unpretentious about any 'artistic' merits their work may possess. It is, I suppose, a fairly healthy stance: certainly more healthy than skipping about and writing a haiku on Spurs v Arsenal. But journalists do rather go on about their professionalism. Indeed, McCabe himself used to revel in the whole thing of being the professional newspaper man: the most important picture in your life is the one you take next Saturday, and all that sort of thing. But you can get blinded by such stuff. McCabe has a phenomenal eye. By nature, he is an artist. He has used his eye to make a series of wonderful, memorable, insightful photographs from the cheerful trivia of sporting events over ten years. He has used the art in him for journalism, and Dr Johnson's words on art still hold good for his newspaper work. Now he has moved on: such is his right.

Journalists are far too bashful to refer to any of their newspaper work as 'art', and there is far too much nonsense talked about art anyway. McCabe's first book was called *Eamonn McCabe: Sports Photographer*. Full of professionalism, that. Perhaps this one should have been called *Eamonn McCabe: Artist*. It would certainly not have been inaccurate, but it does sound a little over the top. So let us settle, in the end, for *Eamonn McCabe: Photographer*. Why not, indeed? 'Photographer' is a label many fine artists have worn with pride.

SPORT

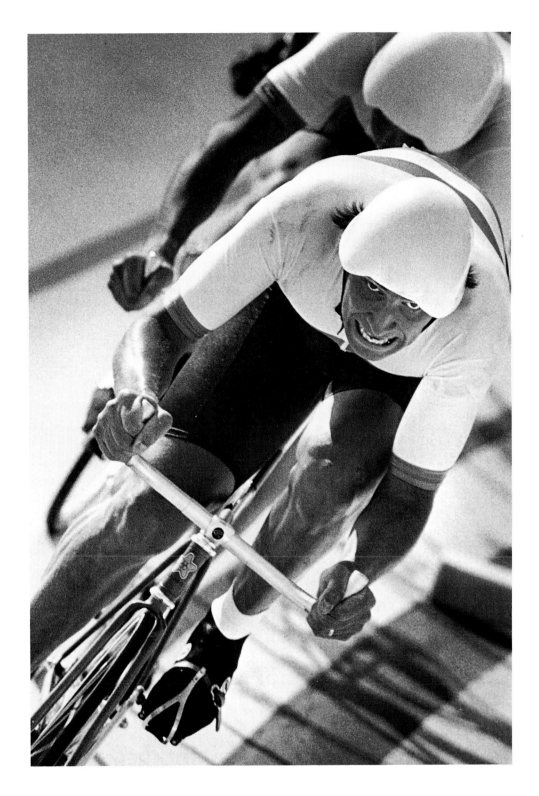

Cyclists, Olympics, Los Angeles, 1984

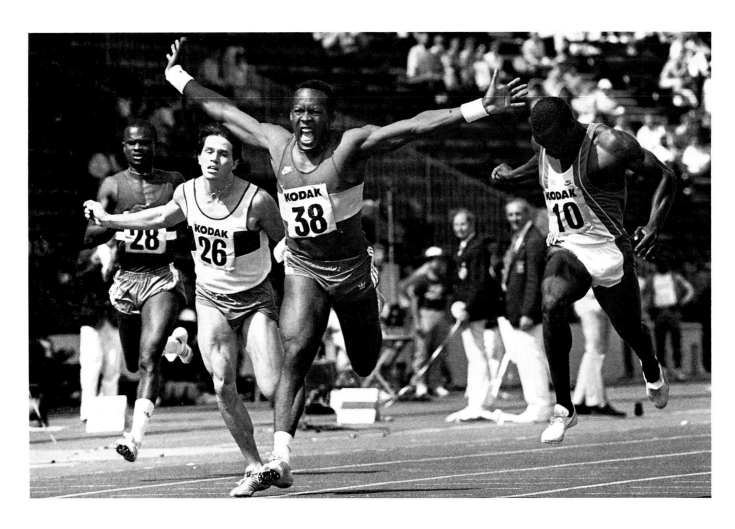

John Regis, Crystal Palace, 1986

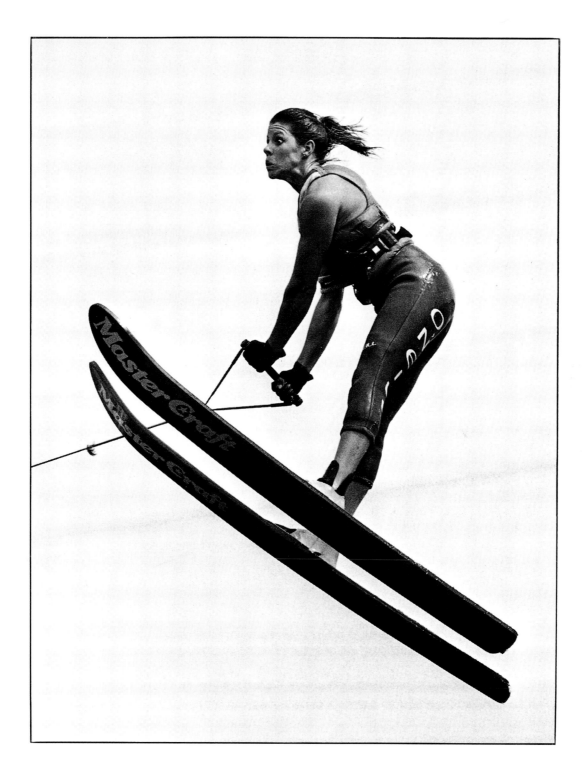

Water–skier, Surrey, 1981

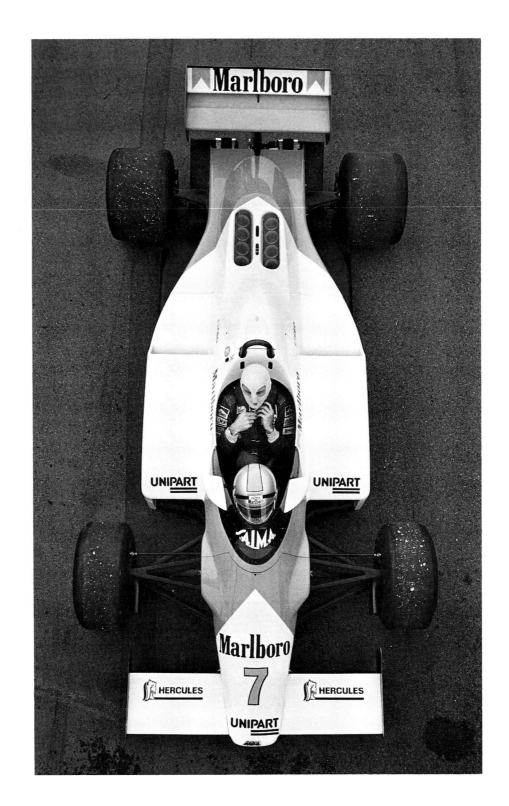

John Watson, Brands Hatch, 1982

John Watson, Brands Hatch, 1986

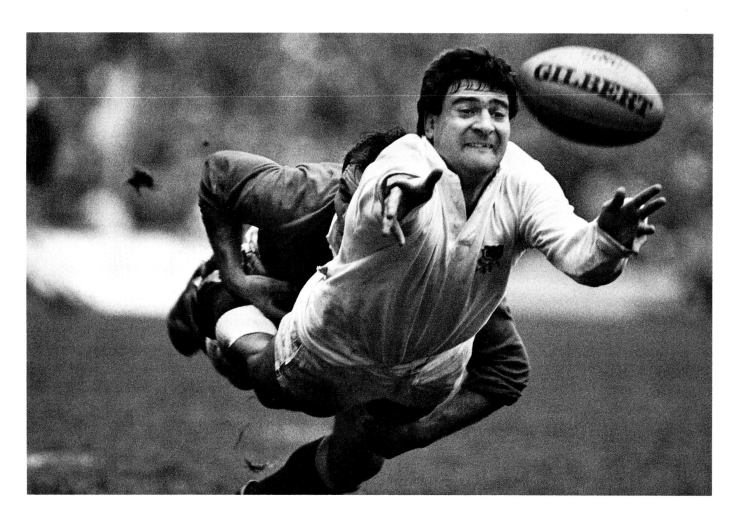

Nick Youngs and Terry Holmes, England v Wales, Twickenham, 1984

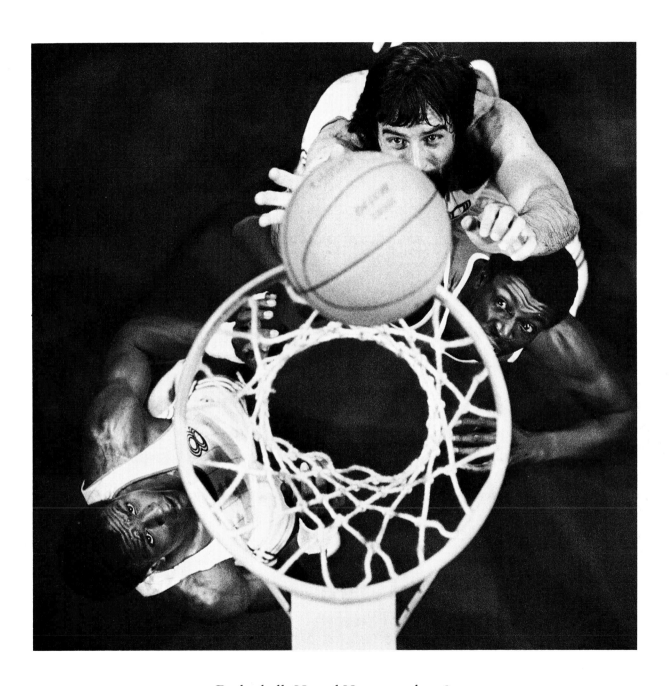

Basketball, Hemel Hempstead, 1982

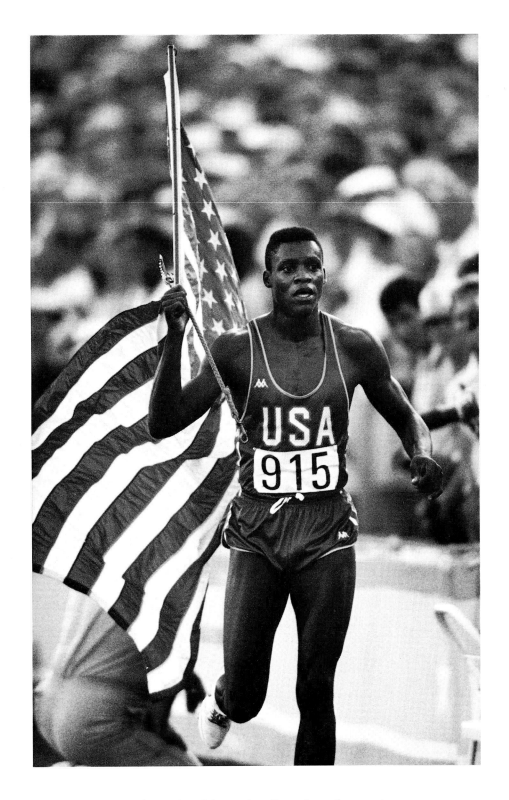

Carl Lewis, Olympics, Los Angeles, 1984

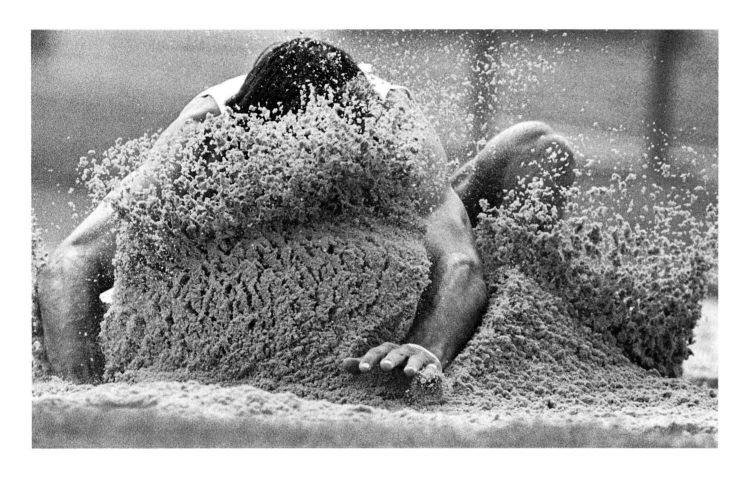

Long Jumper, London, 1985

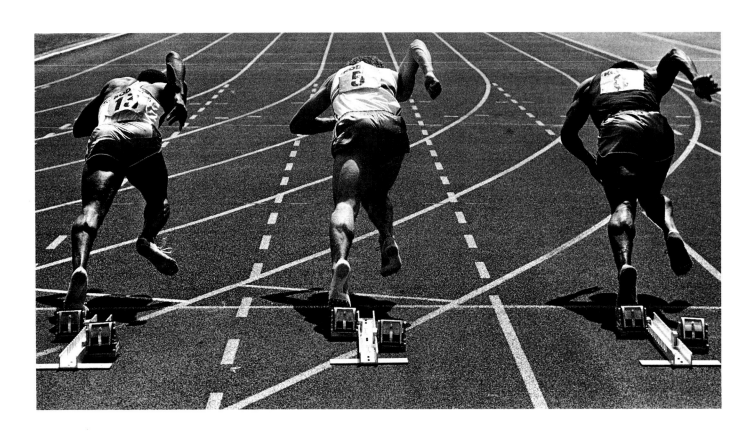

Sprinters, Crystal Palace, 1985

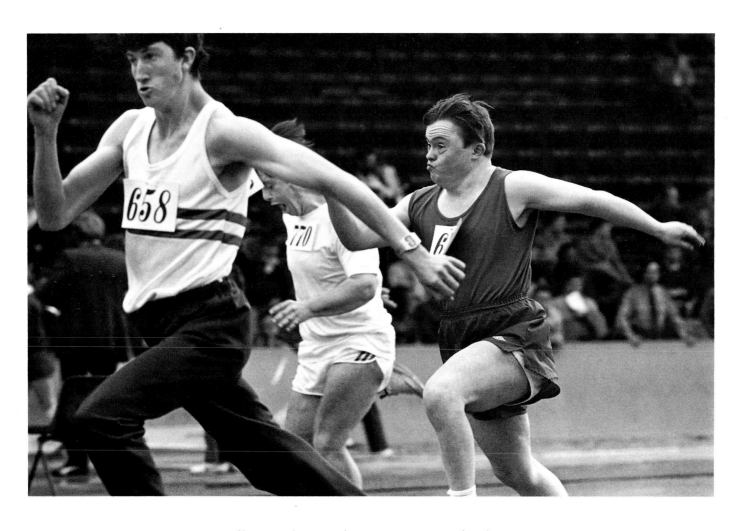

Mentally Handicapped Runners, Crystal Palace, 1986

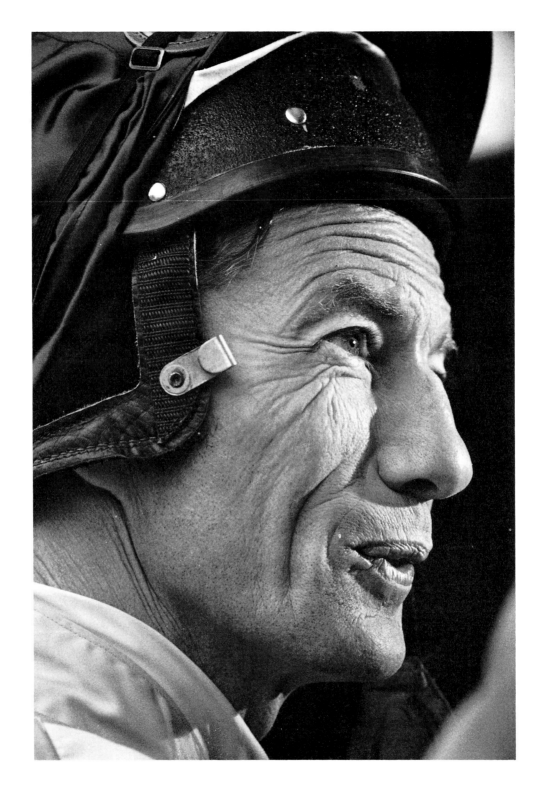

Lester Piggott, Sandown, 1984

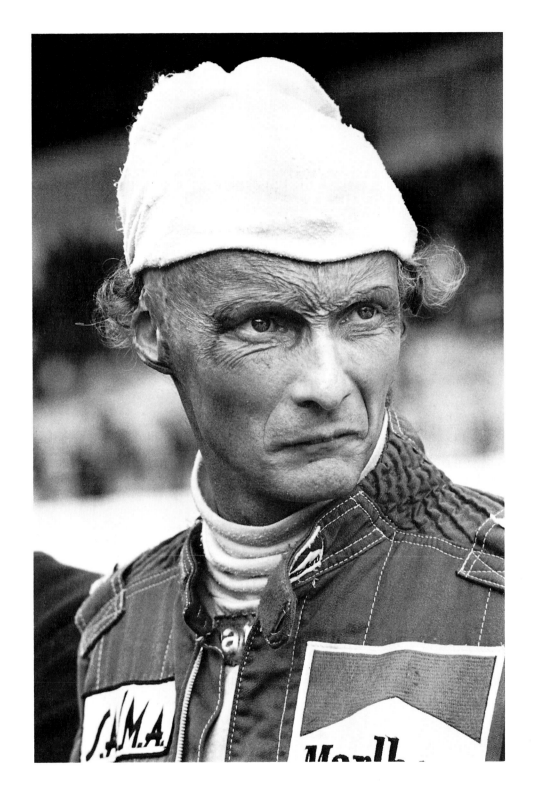

Nikki Lauda, Portugal, 1984

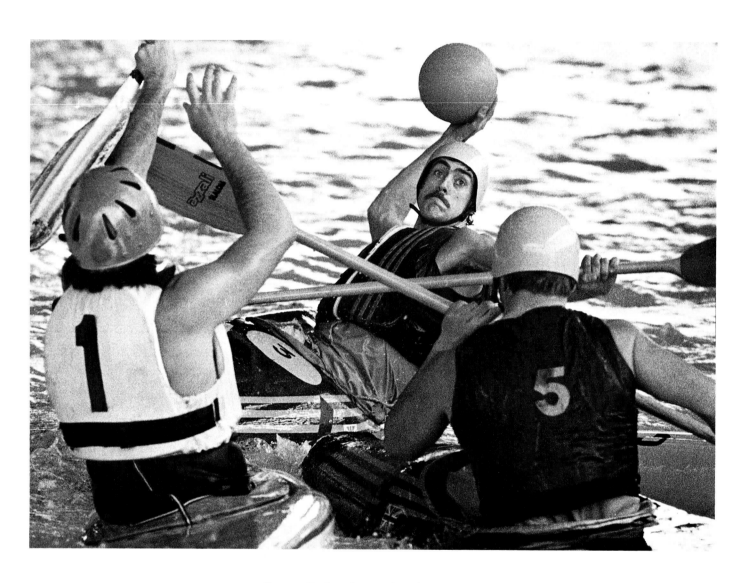

Canoe Polo, Crystal Palace, 1985

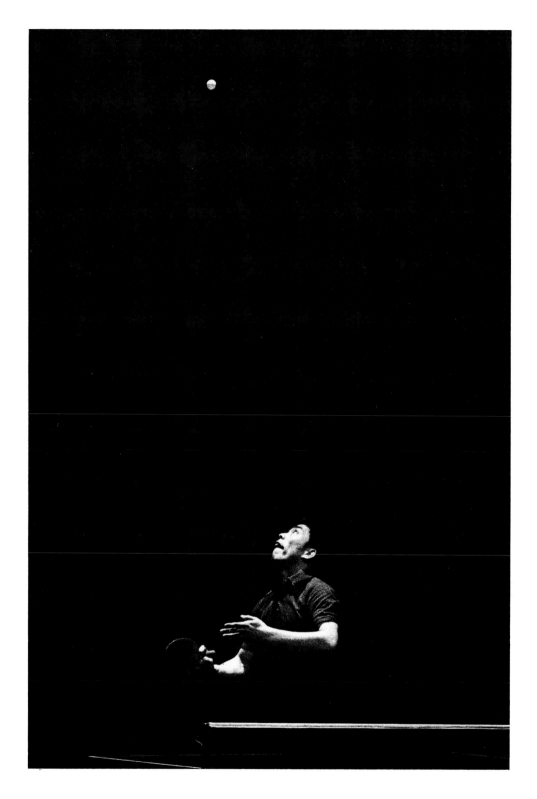

Li Chen Shi, London, 1978

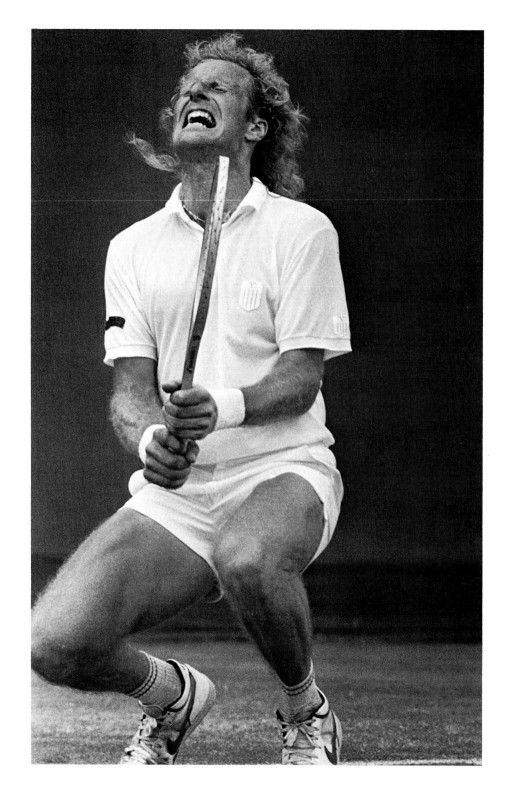

Vitas Gerulaitis, Wimbledon, 1985

HEREWARD COLLEGE
PHOTOGRAPHY DEPT
BRAMSTON CRES.
COVENTRY.

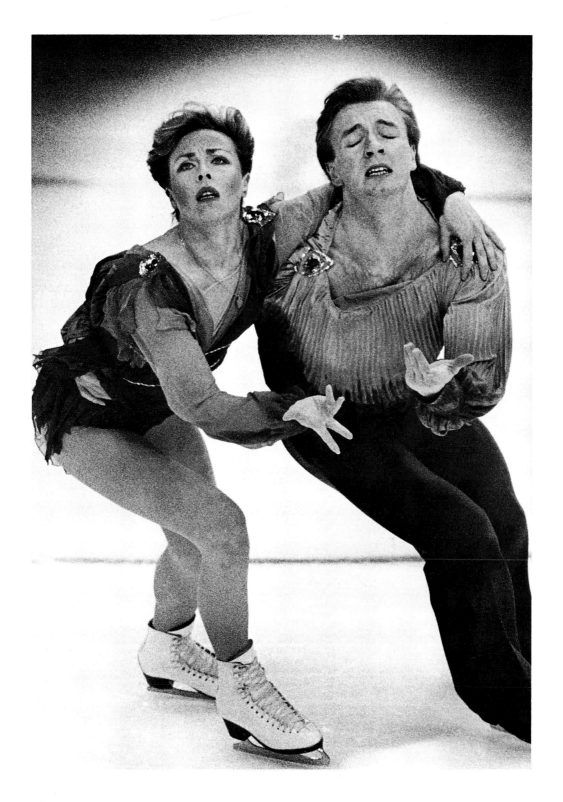

Torvill and Dean, Olympics, Sarajevo, 1984

17

HEREWARD COLLEGE
PHOTOGRAPHY DEPT.
BRAMSTON CRES.
COVENTRY.

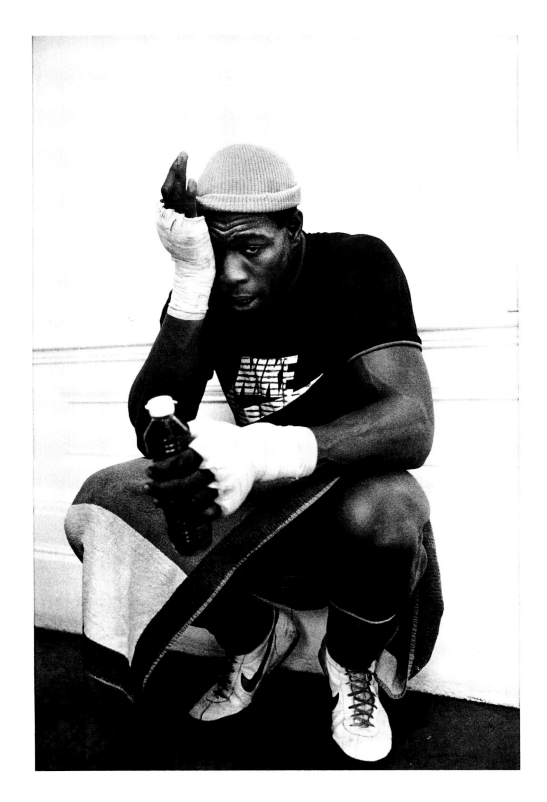

Frank Bruno, Canning Town, 1986

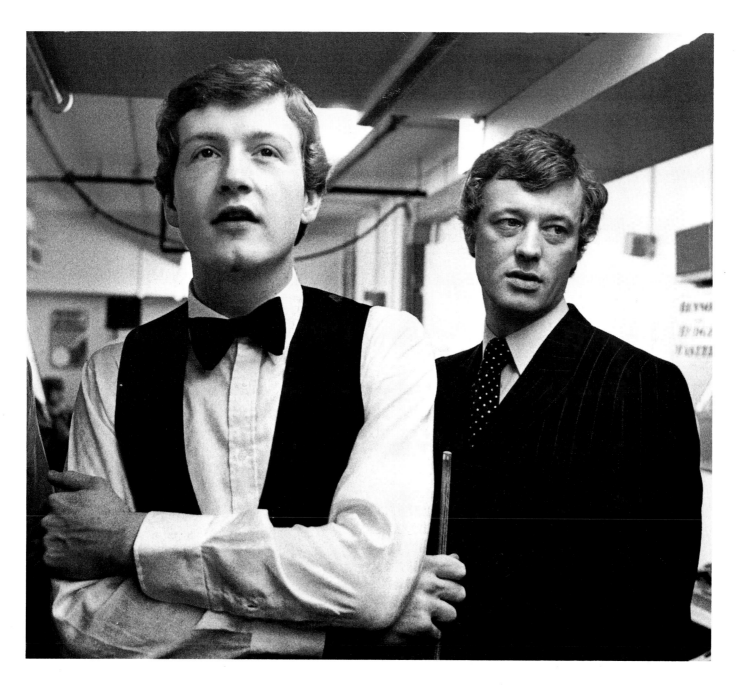

Steve Davis and Barry Hearn, Wembley, 1982

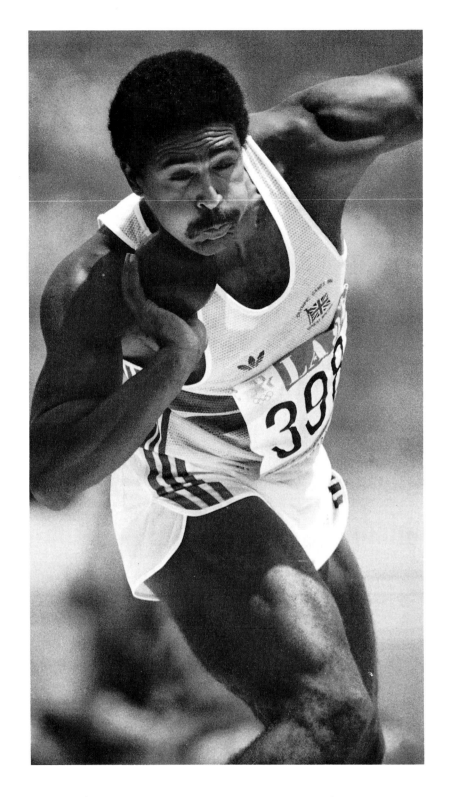

Daley Thompson, Olympics, Los Angeles, 1984

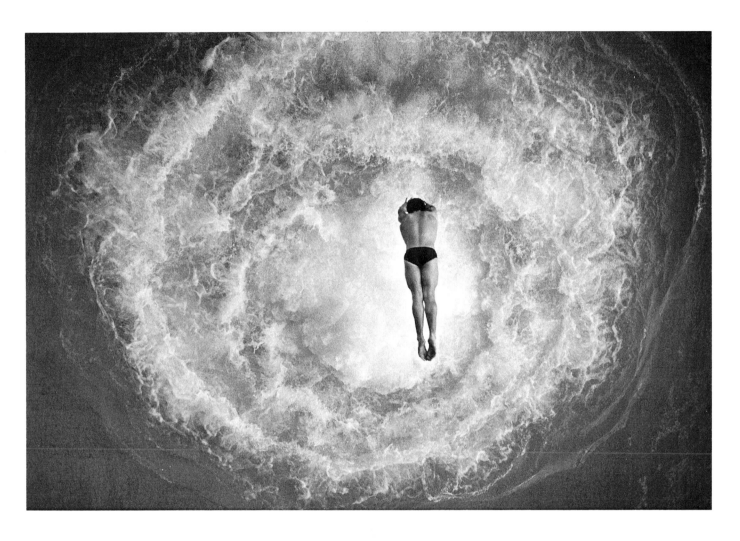

Diver, Crystal Palace, 1984

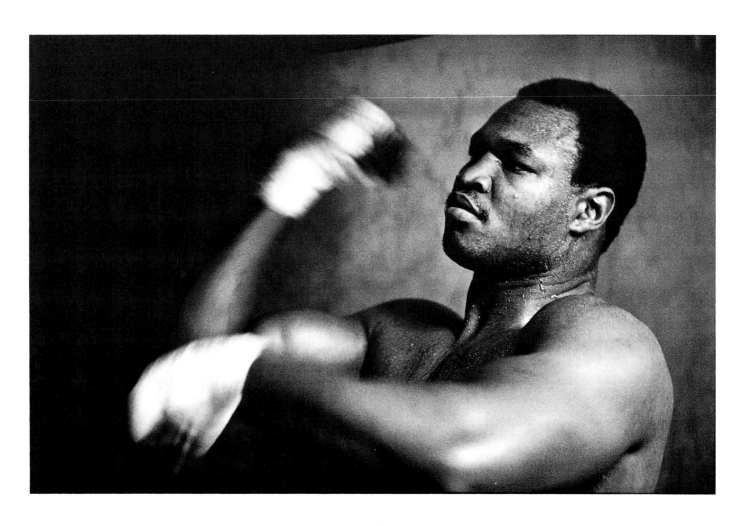

Larry Holmes, Philadelphia, 1981

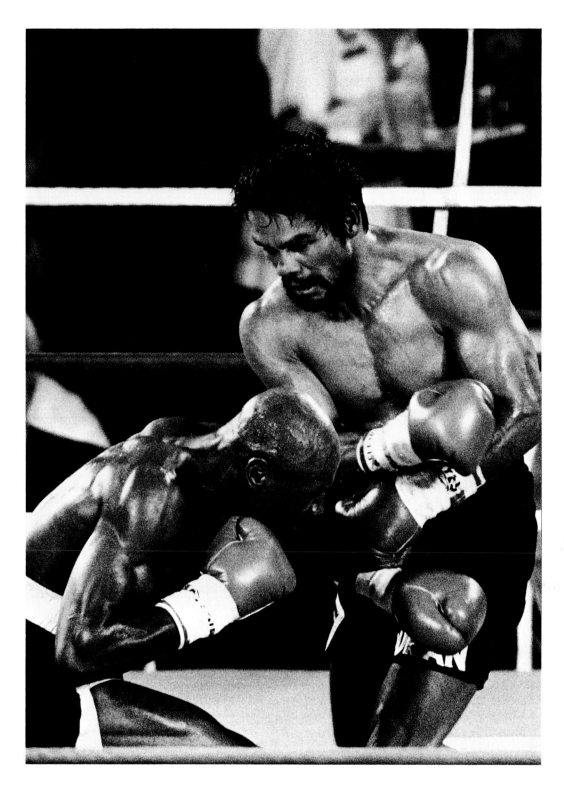

Hagler v Duran, Las Vegas, 1982

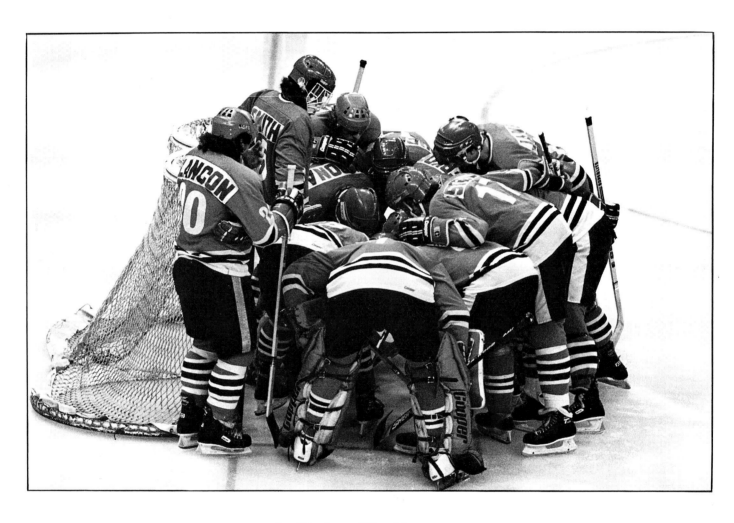

Ice Hockey, Wembley, 1985

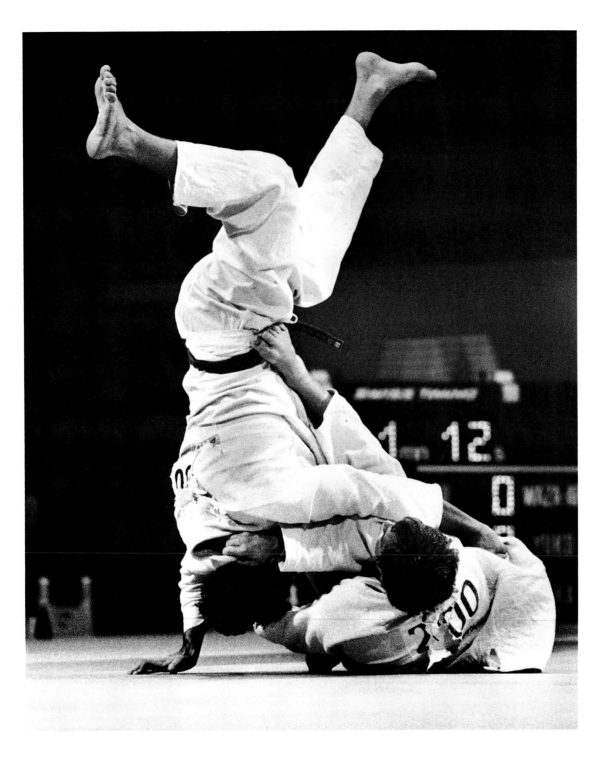

Neil Adams, Olympics, Los Angeles, 1984

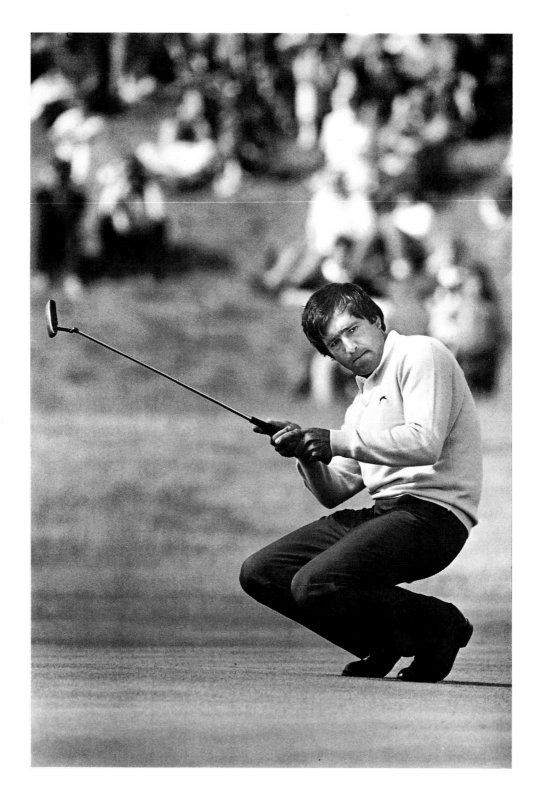

Seve Ballesteros, The Open, 1985

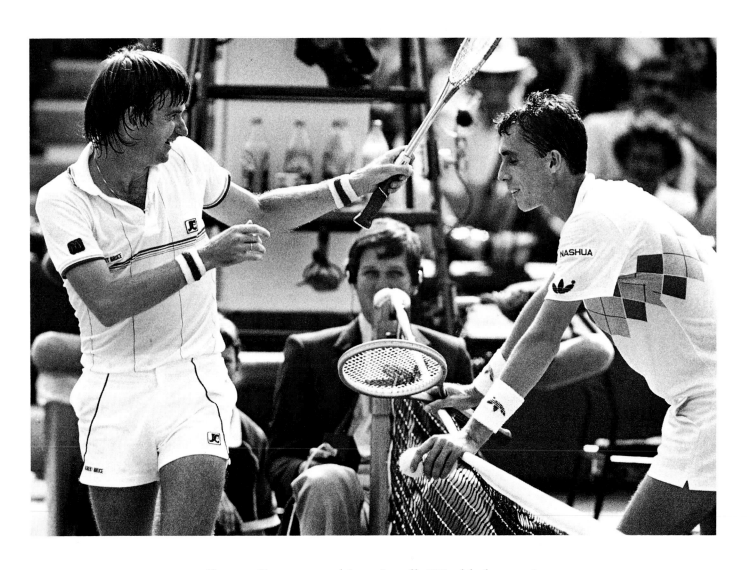

Jimmy Connors and Ivan Lendl, Wimbledon, 1984

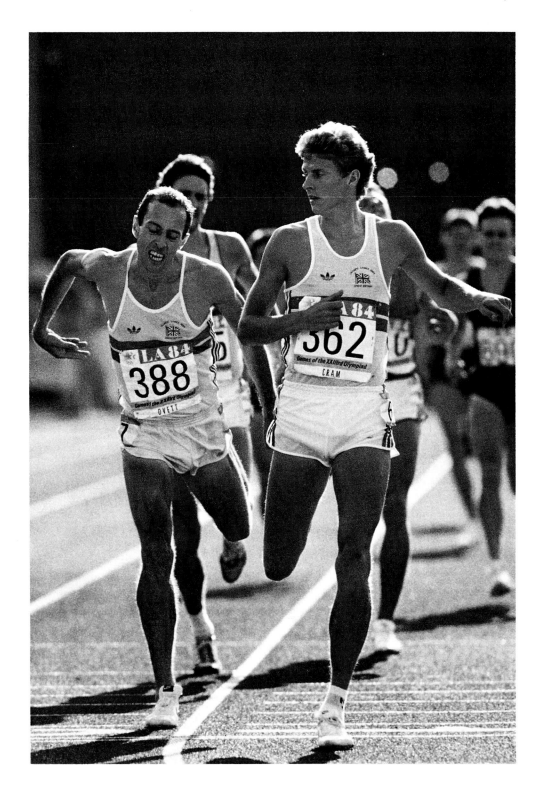

Steve Ovett and Steve Cram, Olympics, Los Angeles, 1984

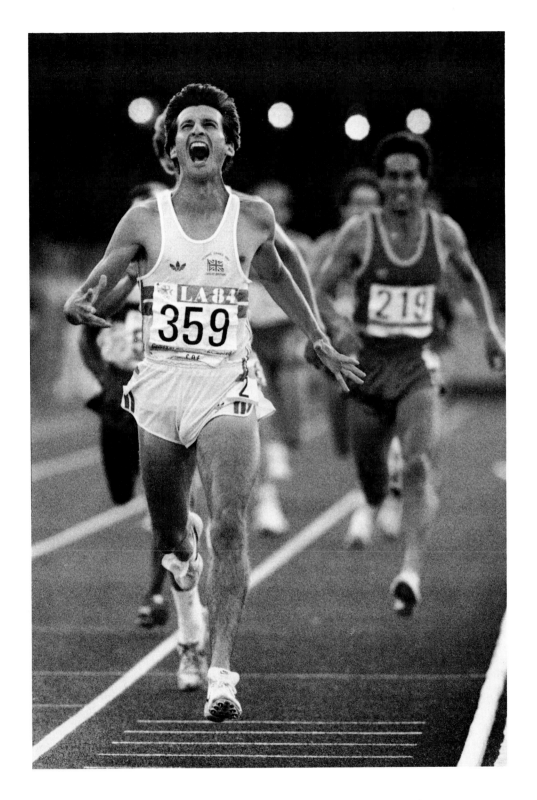

Seb Coe wins 1500 metres final, Olympics, Los Angeles, 1984

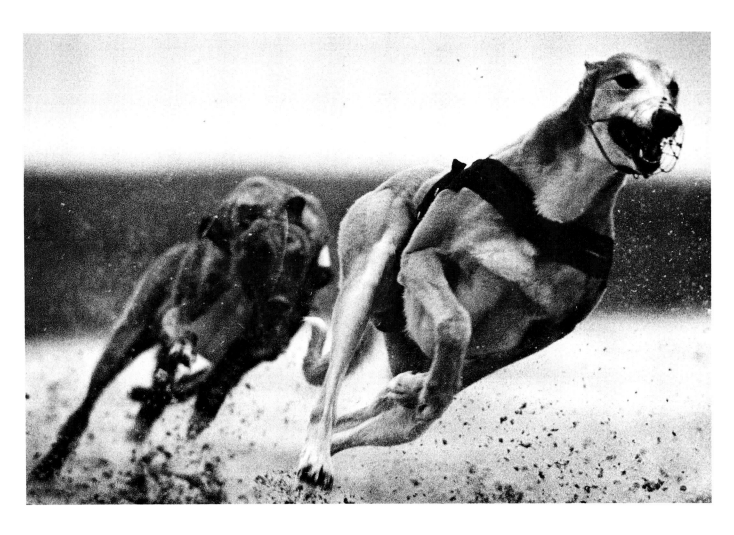

Greyhound Racing, Hove, 1985

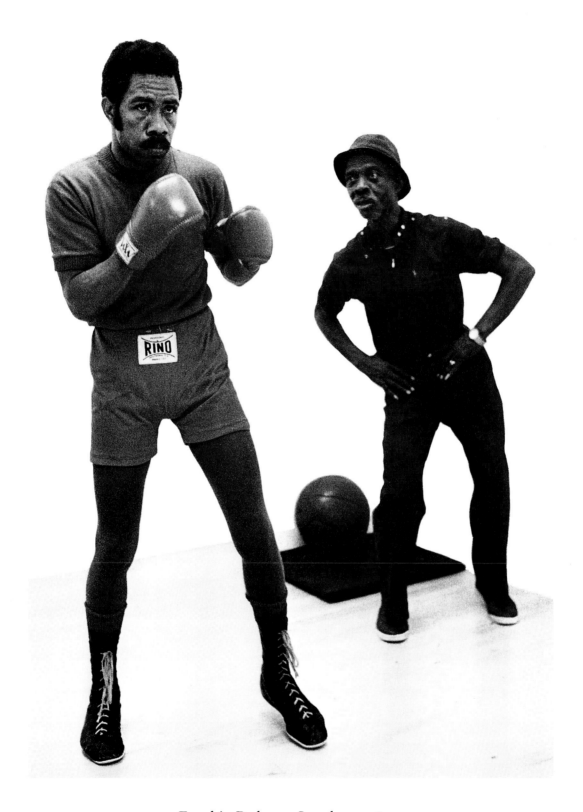

Eusebio Pedroza, London, 1985

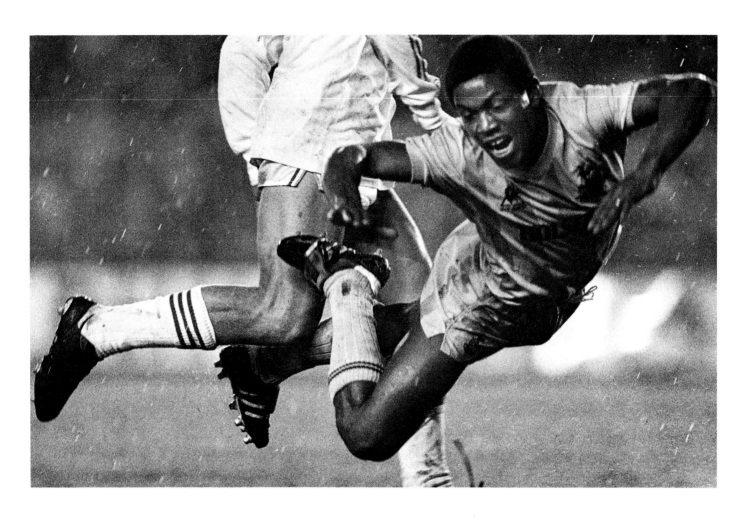

Danny Thomas, Tottenham Hotspur v Real Madrid, 1985

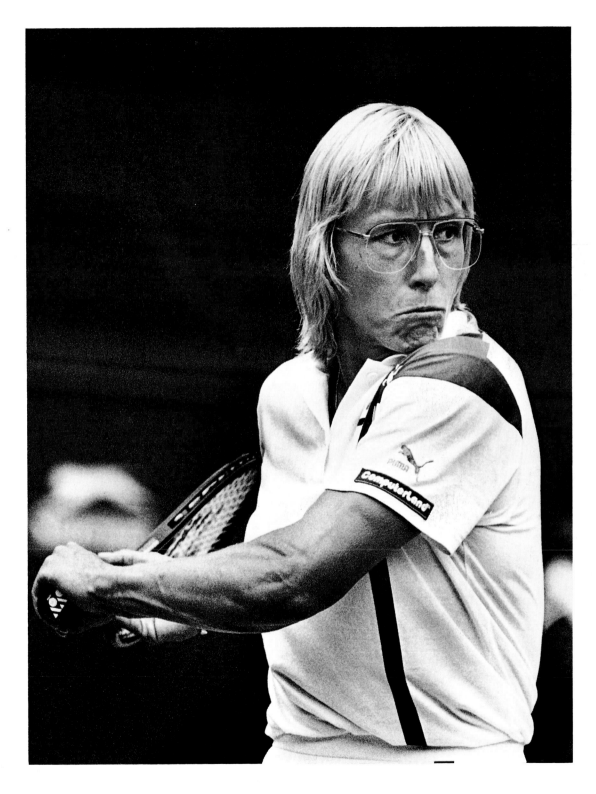

Martina Navratilova, Wimbledon, 1986

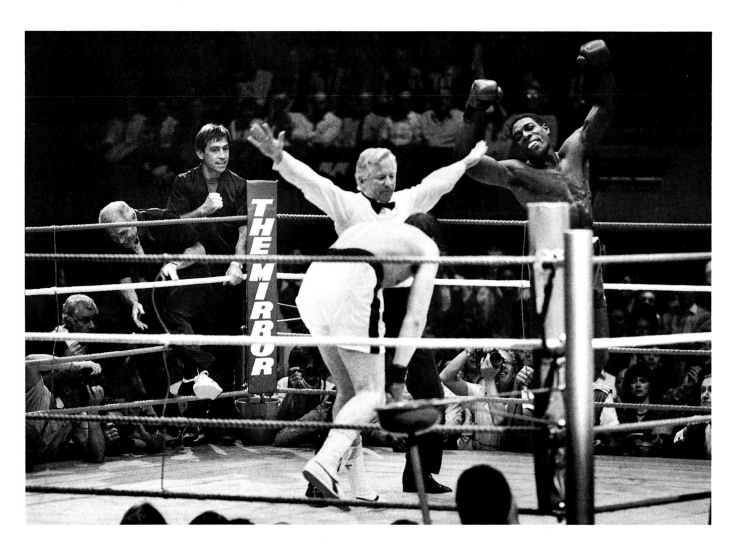

Frank Bruno wins European title, Wembley, 1985

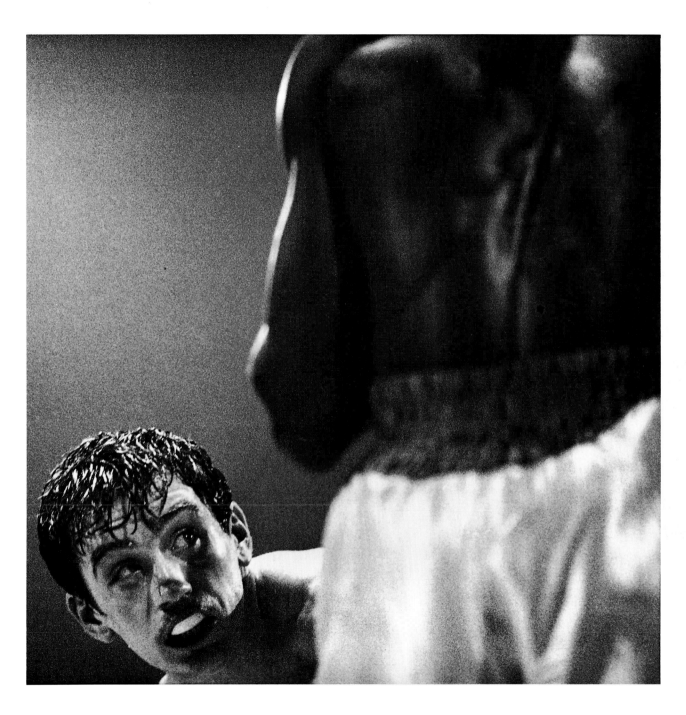

Barry McGuigan, Belfast, 1985

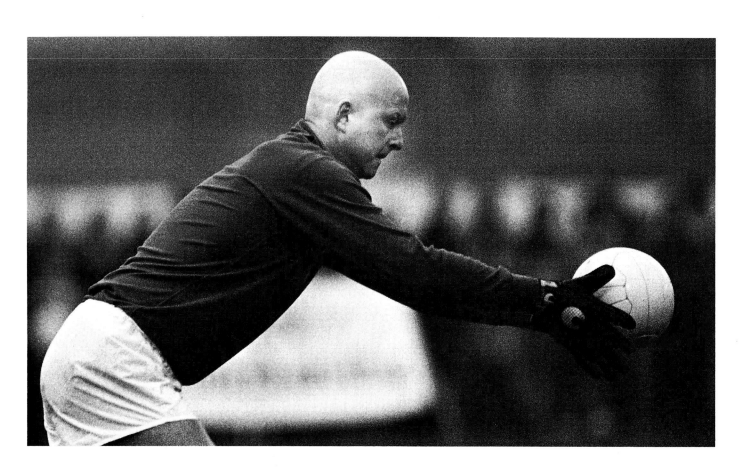

John Shaw, Bristol Rovers v Fisher Athletic, 1984

Soccer School, Lilleshall, 1985

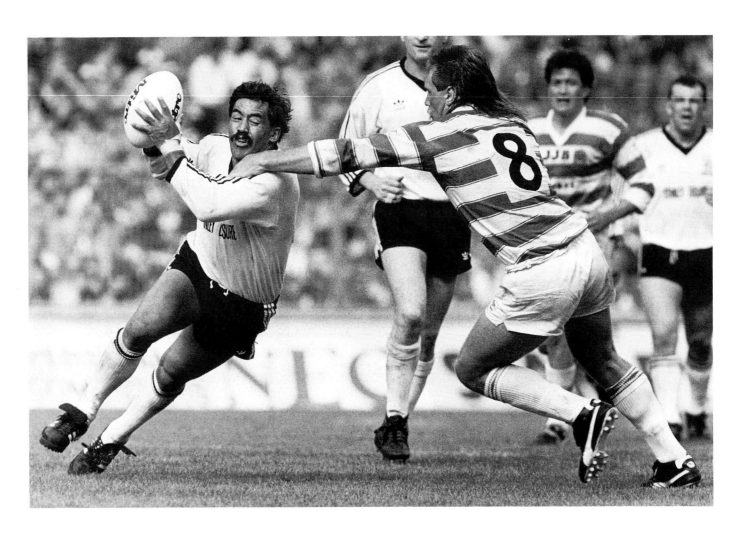

Tamati and Hemsley, Rugby League final, Wembley, 1984

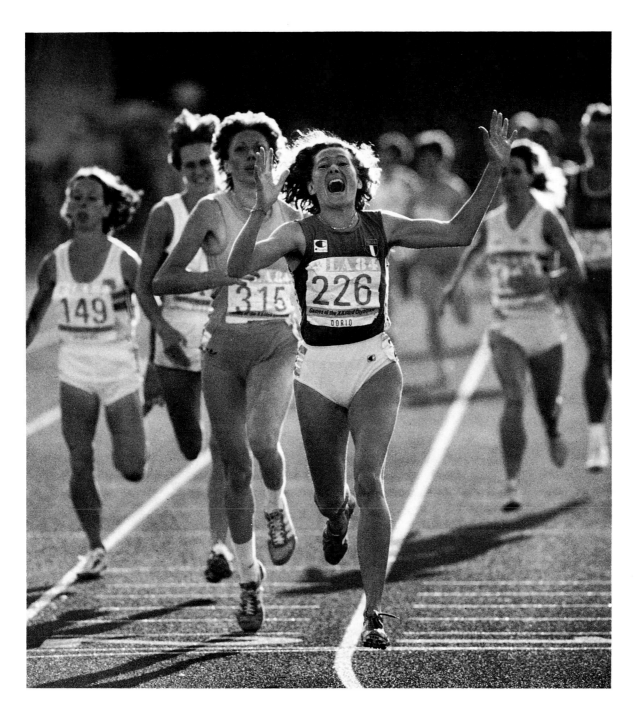

Gabriella Dorio wins 1500 metres final, Olympics, Los Angeles, 1984

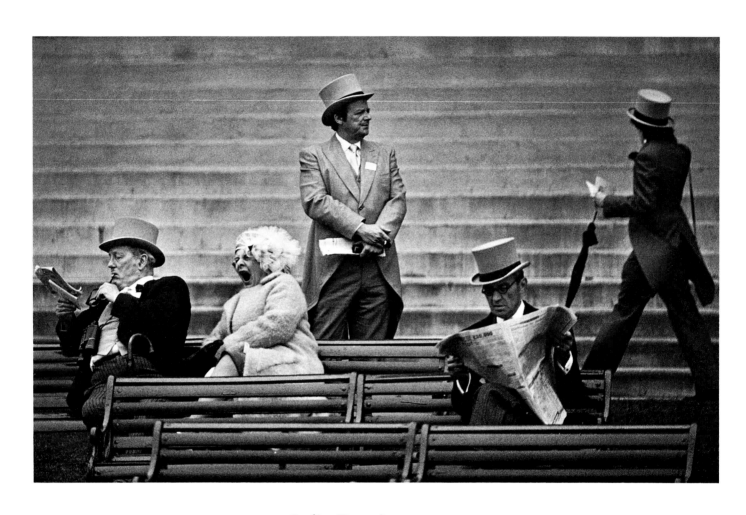

Ladies Day, Ascot, 1977

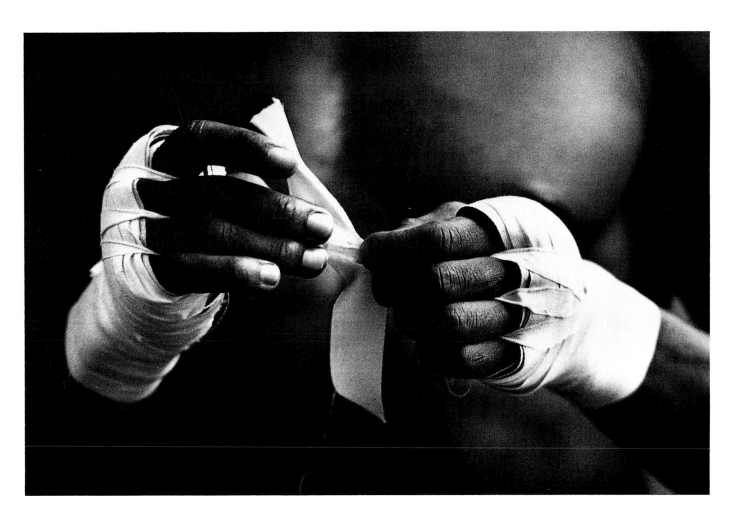

Sylvester Mittee, King's Cross, 1984

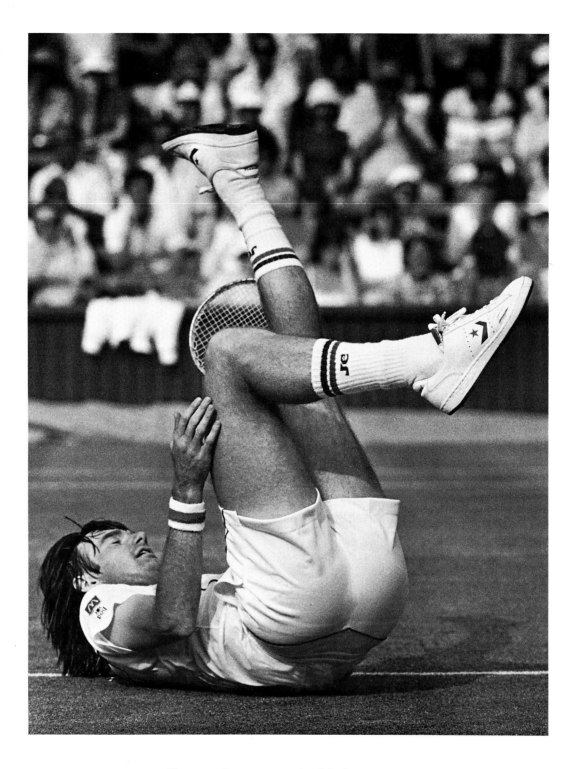

Jimmy Connors, Wimbledon, 1985

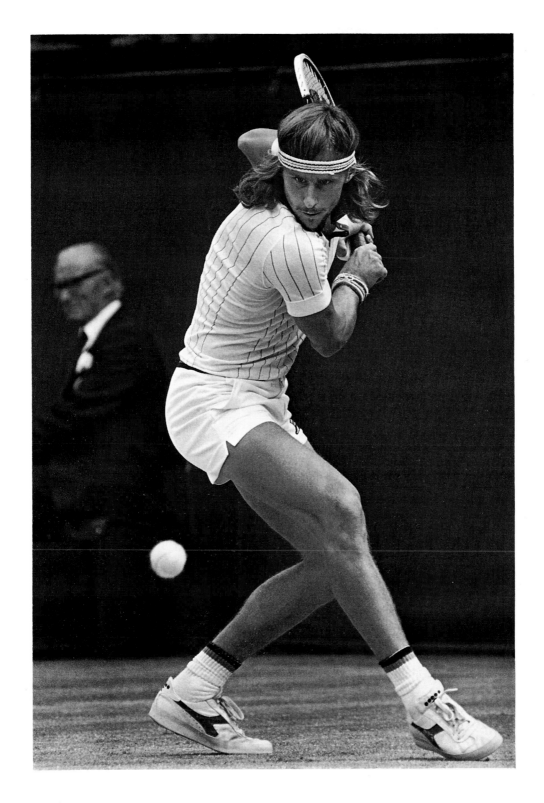

Bjorn Borg, Wimbledon, 1978

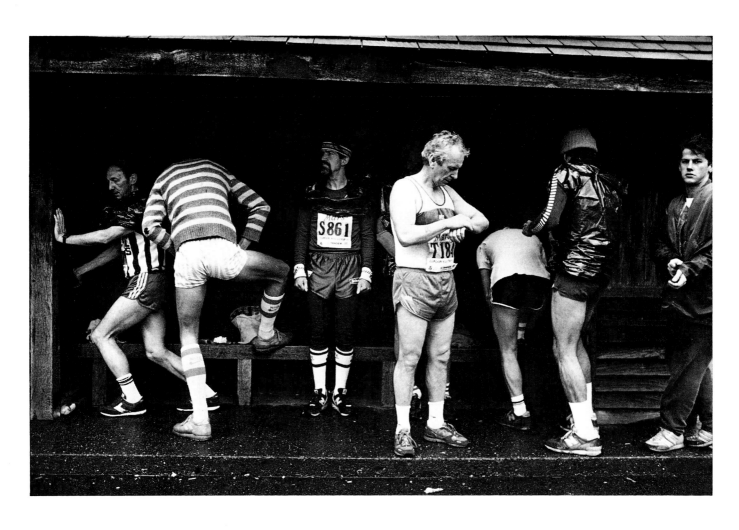

Marathon Runners, London, 1986

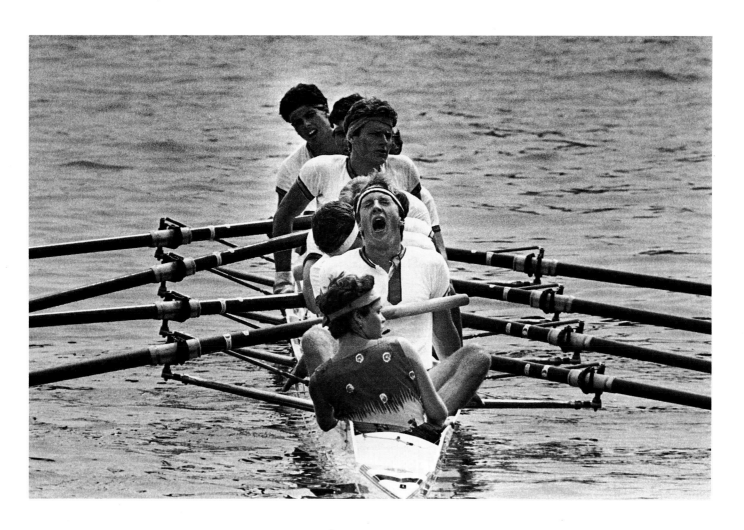

Henley Regatta, 1986

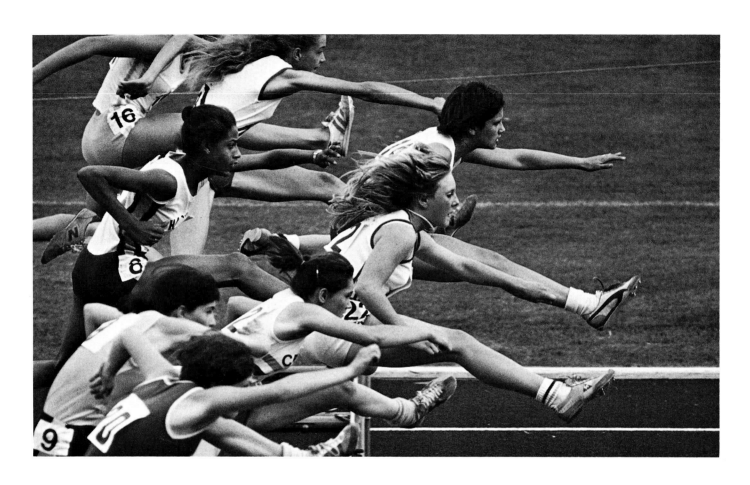

Crystal Palace, 1982

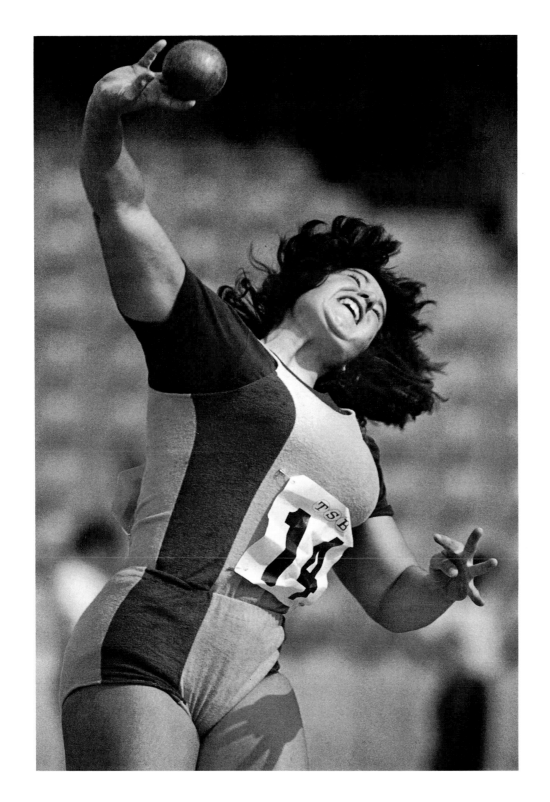

Judith Oakes, Crystal Palace, 1981

47

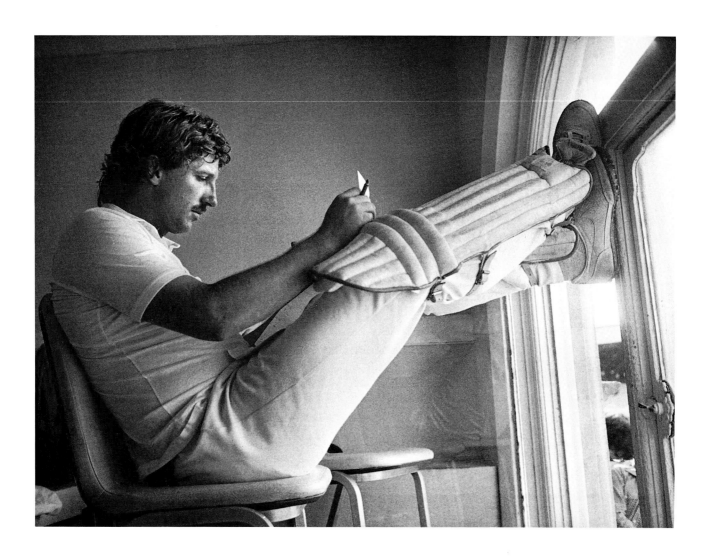

Ian Botham, The Oval, 1982

HEREWARD COLLEGE
PHOTOGRAPHY DEPT.
BRAMSTON CRES.
COVENTRY.

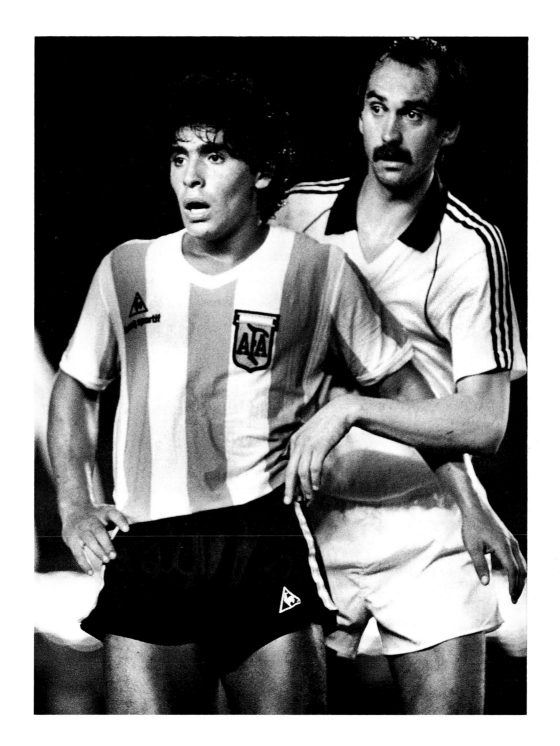

Maradona and Stielike, Buenos Aires, 1982

HEREWARD COLLEGE
PHOTOGRAPHY DEPT.
BRAMSTON CRES.
COVENTRY.

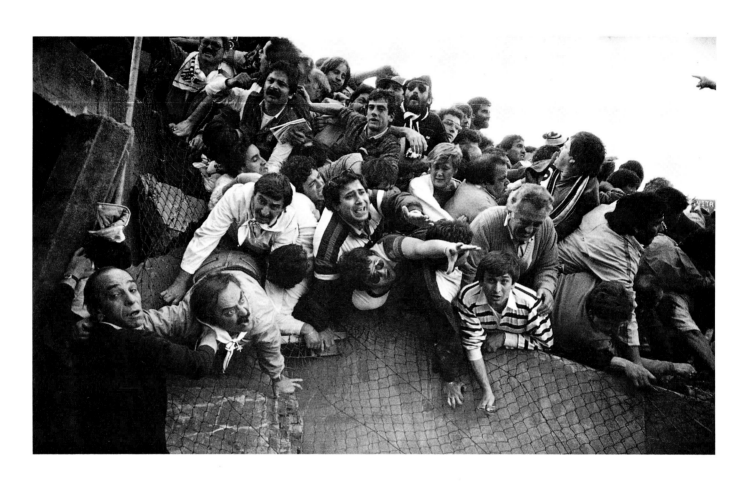

Heysel Stadium, Brussels, 1985

LANDSCAPES

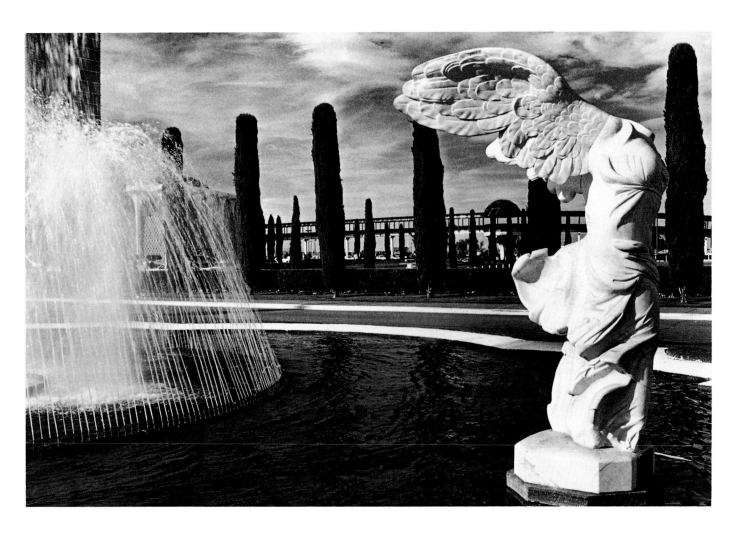

Las Vegas, 1983

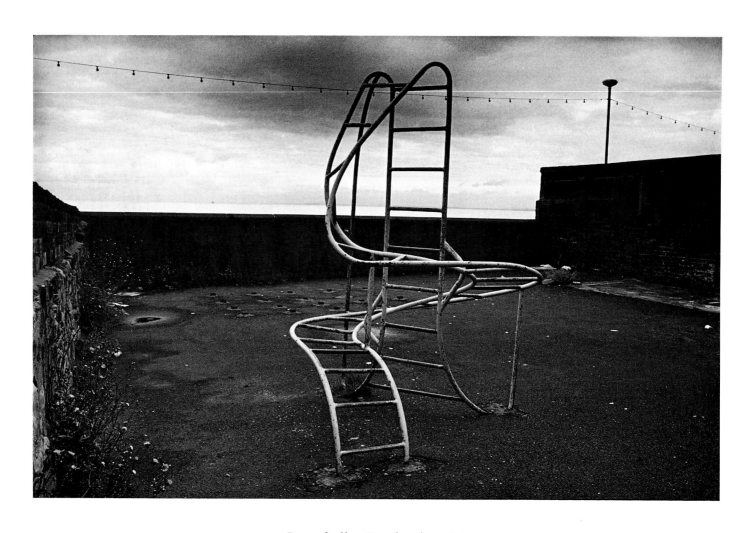

Portobello, Scotland, 1986

Portobello, Scotland, 1986

Cromer, Norfolk, 1986

Miami, 1985

Las Vegas, 1983

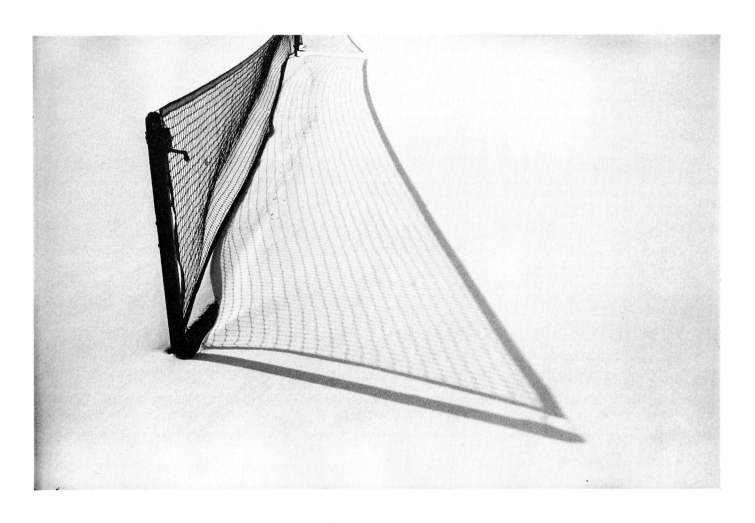

Highgate, London, 1986

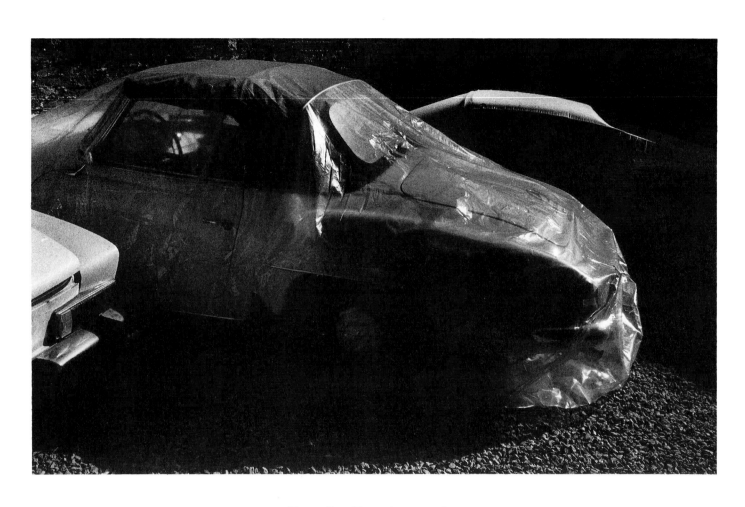

Cars, San Francisco, 1984

Arlington, Texas, 1984

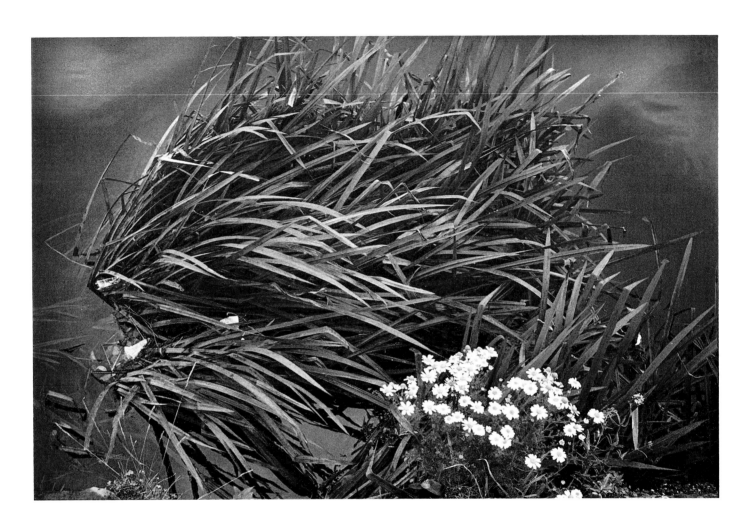

Trent Park, London, 1986

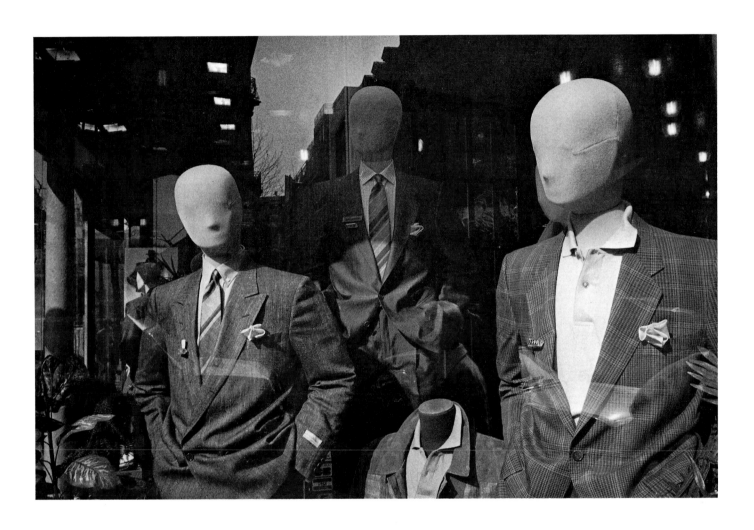

Paris, 1986

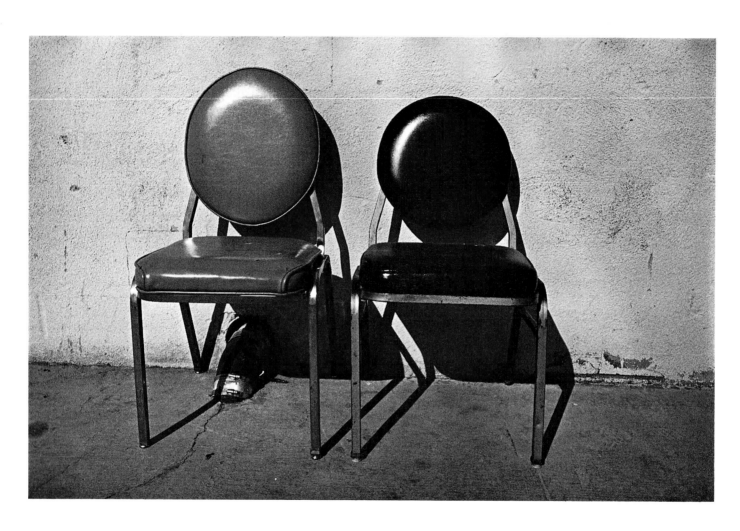

Las Vegas, 1983

St Tropez, 1984

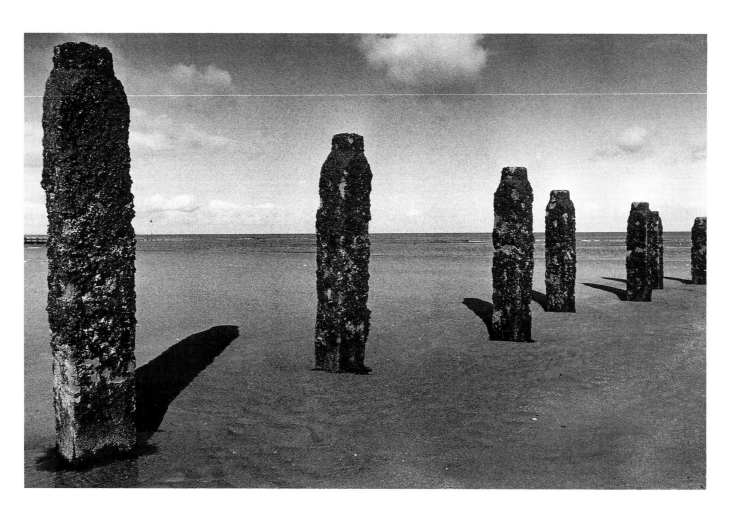

Rhyll, North Wales, 1986

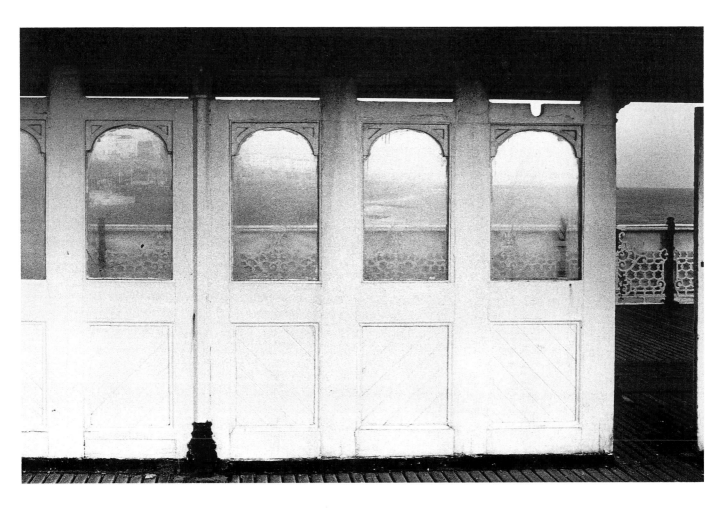

Brighton, 1986

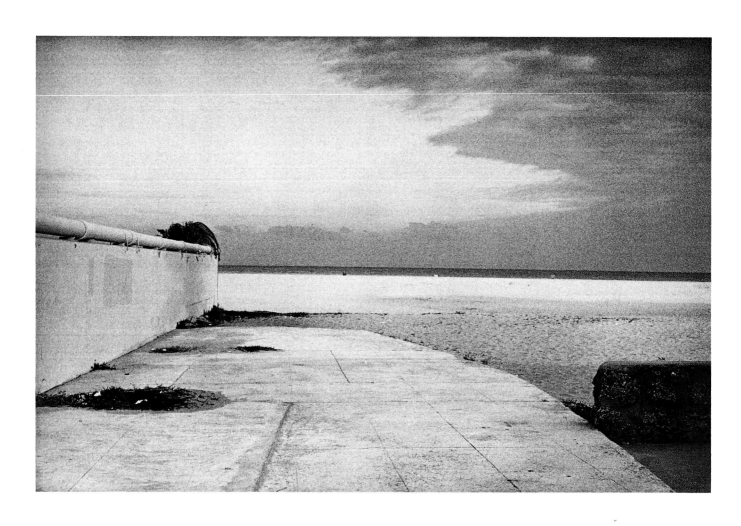

Miami, 1984

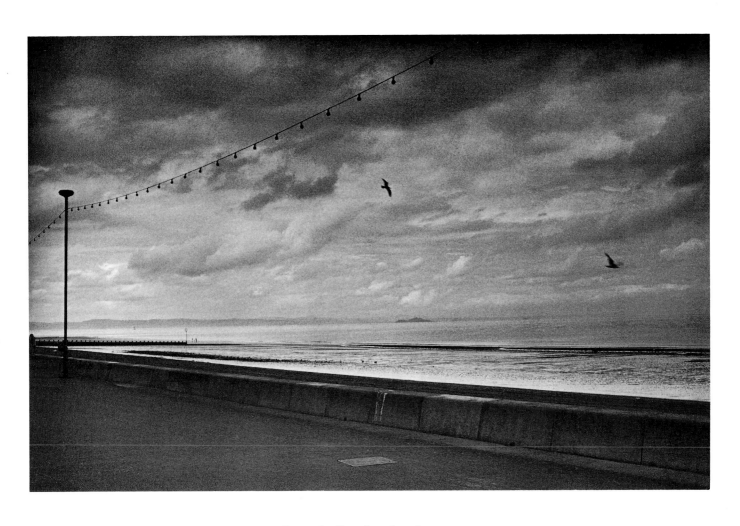

Portobello, Scotland, 1986

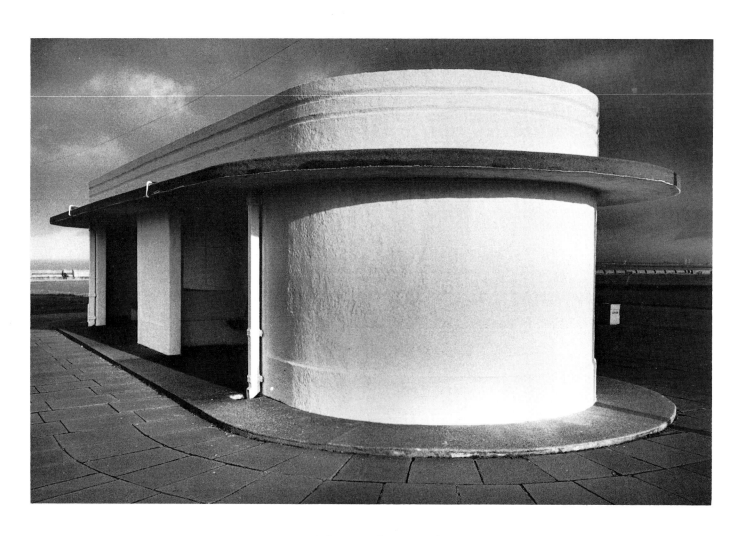

New Brighton, The Wirral, 1985

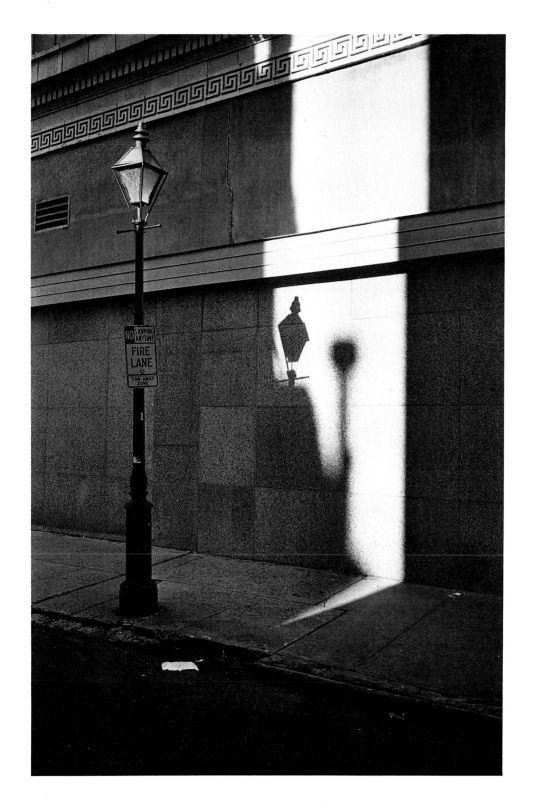

Oakland, California, 1984

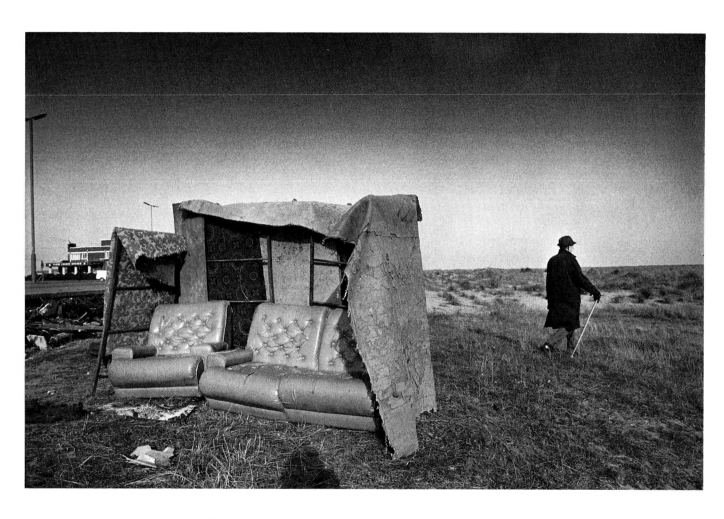

Great Yarmouth, Norfolk, 1986

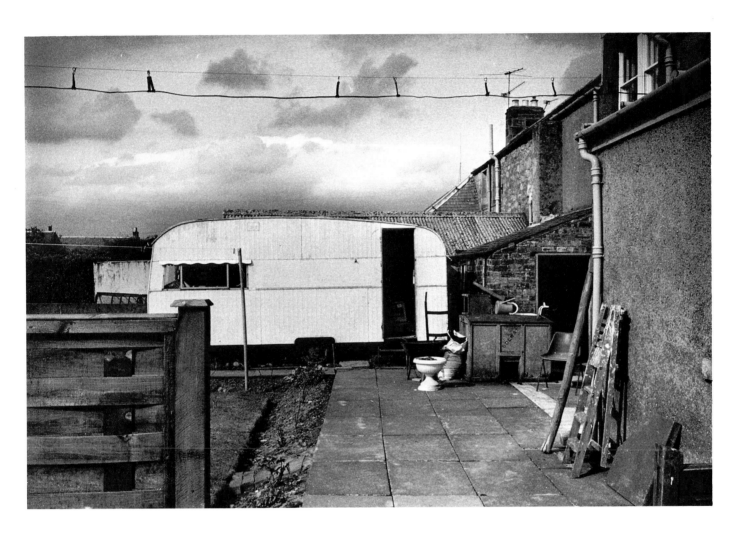

Newtown, Scotland, 1986

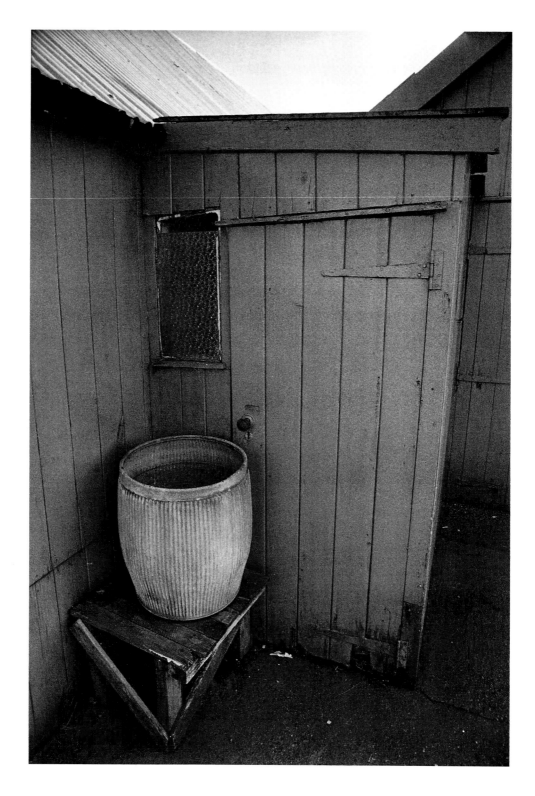

Holt, Norfolk, 1986

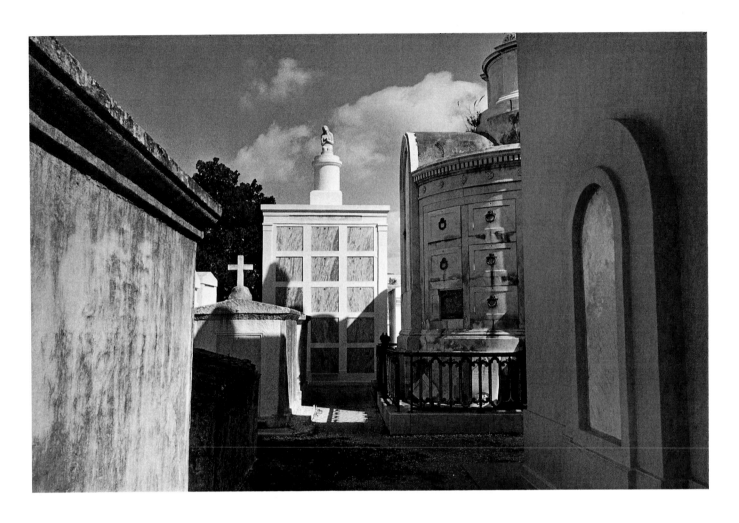

New Orleans, 1986

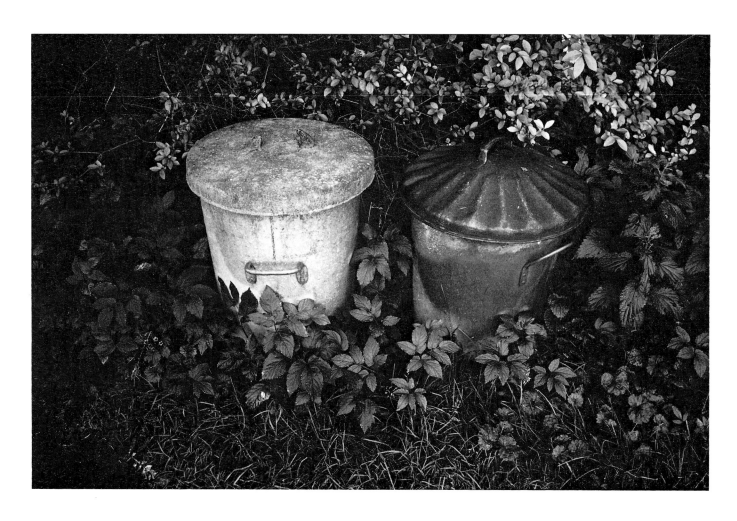

Brome, Suffolk, 1986

HEREWARD COLLEGE
PHOTOGRAPHY DEPT.
BRAMSTON CRES.
COVENTRY

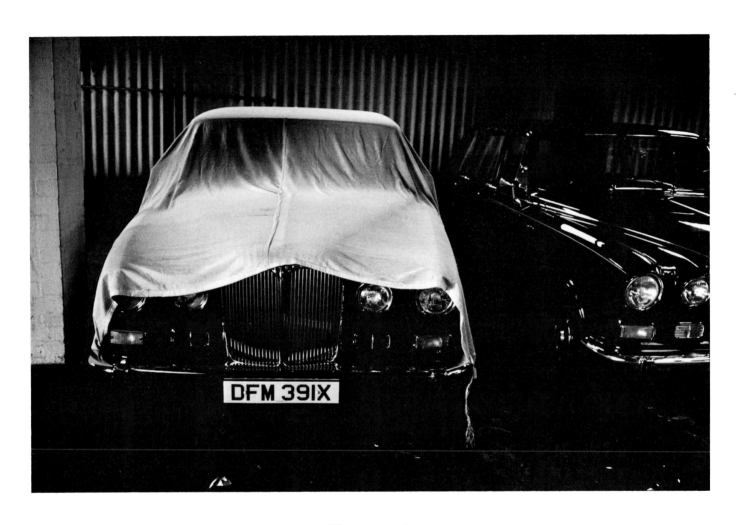

Chester, 1986

HEREWARD COLLEGE
PHOTOGRAPHY DEPT.
BRAMSTON CRES.
COVENTRY.

Arlington, Texas, 1984

Edinburgh, 1986

Leicester Square, London, 1986

Keith and Sally Bamber, London, 1986

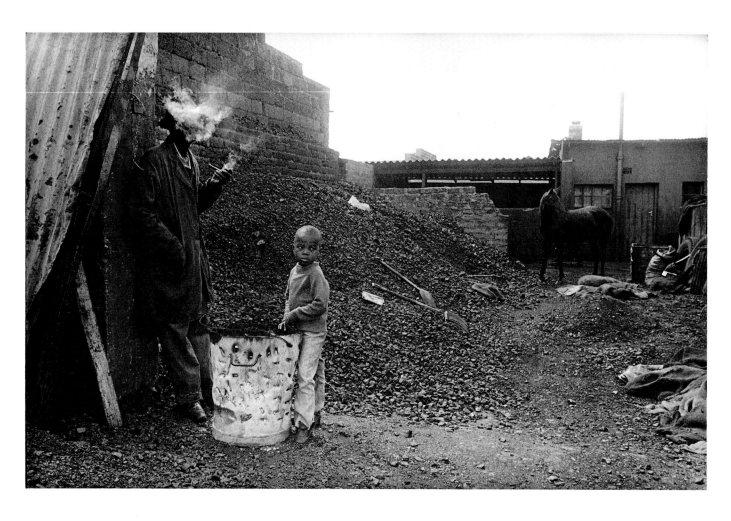

Soweto, South Africa, 1979

NOTES TO PHOTOGRAPHS

1 CYCLISTS
400mm: 400 ASA: 1/1000th @ f2.8.

'I like the way this looks like a thirties movie. The helmet gives it strength. I was leaning over the edge of the velodrome, watching the teams come round. Some guys have their eyes closed, others keep their heads right down. But this guy was one of those photographable people, with a lot of dynamism and life about him. I had the same picture in colour, actually, but someone stole the film at the Olympics. Some free-lance photographers are very competitive people. It was nicked from a photographer's rest area in Los Angeles, while I was winding down over a beer. Pretty low, that.'

2 SPRINTER: JOHN REGIS
300mm: 400 ASA: 1/1000th @ f5.6.

I like the way this shows the sheer joy of winning. This is John Regis, brother of Cyrille the footballer. It is very dangerous, shooting black fellows against black backgrounds, but I got away with it that time.'

3 WATER-SKIER
300mm: 400 ASA: 1/1000th @ f8.

'It is very difficult to get a clean picture of this sport. You have to pre-focus – people who say they don't are lying. It's too fast. I noticed that this competitor kept pulling the most extraordinary expressions as she jumped. She looks as if she is about to fly into the back of a bus. After I had seen that, the only problem was to move around until I had no tree or telegraph poles in the background. And to hope she did it again.'

4 RACING CAR: JOHN WATSON
35mm: 400 ASA: 1/500th @ f5.6.

'This is one of the rare occasions when I have set up a shot. It was with John Watson, who was tremendously helpful. I went there with the idea of taking a car from above: the angle you never get to see normally. I went to Brands Hatch, and the track was closed, so we pushed the car to a bridge and I leant from the top. I like the colour contrasts: black white black white. This is one *The Observer* used well and big.'

5 JOHN WATSON, CARAVAN
35mm: 800 ASA: 1/60th @ f2.8.

'This was another set-up with John Watson on another occasion. What a helpful guy: people like him make your job easy. I wanted him preparing for a race in his caravan, with a kind of 2001 feel: "you won't get very far without your helmet, John". I asked if I could take a picture of him getting dressed, and he said, so long as he wasn't expected to pose stark naked, fine.'

6 RUGBY: TERRY HOLMES
400mm: 800 ASA: 1/500th @ f3.5.

'I am pleased with this, since I don't pride myself on peak-of-the-action stuff. Terry Holmes is one of those personalities you need to make good pictures. When I

started, it was people like Jimmy Greaves and Denis Law who made them. Now, the personalities are like policemen: they keep getting younger, and harder to treat with the same respect. Difficult to be *excited* by today's players, anyway. This shot was the last frame on the reel, and only super Holmes would have caught the man. I've always enjoyed rugby. Though I've always played football, my rugby shots have been more satisfying than my football stuff. Rugby seems more of a sport, somehow.'

7 BASKETBALL
85mm: 1600 ASA: 1/500th @ f2.8.

'This was done with a remote control camera taped up to the backboard. The match was televised, so I had their lighting to help out. I used a 100 exposure film, and a special back on the camera body – this is frame 77A. It is the eyes of the players that make it. The problem with a picture like this is that you often get the ball too big in the frame.'

8 CARL LEWIS
400mm: 400 ASA: 1/1000th @ f5.6.

'This said more about Carl Lewis, with all his patriotic projection, than a picture of him sprinting. There is a kind of vulnerability about him. I got him with this very long lens, and as a working picture, I was pleased with it.'

9 LONG JUMPER
400mm: 400 ASA: 1/1000th @ f5.6.

'Ideally, I would have liked a bit more eye in the picture. But I like the way the sand has frozen. You have to be careful not to put the competitors off on an occasion like this: sit dead still.'

10 SPRINTERS
85mm: 400 ASA: 1/1000th @ f8.

'I like the patterns in this very much. I was lucky in that they all started on the same foot. This is one of those that never got into *The Observer*. It was picked up by a firm that does postcards, believe it or not. But it didn't mean anything to the people at *The Observer*: newspaper work can be very frustrating.'

11 MENTALLY HANDICAPPED RUNNERS
180mm: 400 ASA: 1/1000th @ f4.

'This is a Games for mentally handicapped people at Crystal Palace, and it is hard subject to take a newspaper picture of. You don't want to be patronising; you don't want to upset people. I was really impressed with the event, and I hope the picture shows some of my admiration for these guys.'

12 LESTER PIGGOTT
300mm: 400 ASA: 1/500th @ f8.

'I used the 300mm lens to eliminate the background completely. It makes for much more drama, but it is a gamble. You have to get the focus absolutely accurate. It's not the way to get a safe frame.'

13 NIKKI LAUDA
180mm: 400 ASA: 1/500th @ f8.

'I'd never have got a shot like this by setting it up. By watching and waiting, I got this: I think better than a formal portrait could have been.'

14 CANOE POLO
180mm: 800 ASA: 1/500th @ f2.8.

'It's always nice to get a good peak-of-the-action shot – no matter what the sport is.'

15 TABLE-TENNIS: LI CHEN SHI
85mm: 1600 ASA: 1/60th @ f2.

'I include this shot with apologies to those who have seen it more than once before. I took it a long time ago, but I am still pleased with it. A table tennis competition is one where you have freedom to move about, and so I was able to manoeuvre until I had got rid of a lighted Exit sign and had the background I wanted: absolutely nothing.'

16 VITAS GERULAITIS
180mm: 400 ASA: 1/1000th @ f8.

'He is one of those great blokes to take pictures of. He's always doing something, showing it all in his face. He's a terrific over-the-top guy. Photographers need people like him.'

17 TORVILL AND DEAN
300mm: 1600 ASA: 1/500th @ f2.8.

'This sport is a photographer's dream: for once you know exactly what the competitors are going to do. The problem is to get two faces in; you don't want one face and a bum. I noticed one point in their routine where they faced the same way with this great romantic gesture. So it was then a question of getting to the right end of the stadium for it. I was able to watch them in practice, so I was all right. The tricky thing is the exposure, all the extra light reflected from the ice. You must know exactly what you are exposing for: forget the ice, you want the tone of the face.'

18 FRANK BRUNO
180mm: 800 ASA: 1/60th @ f4.

'I'd been trying to take some gym stuff of Bruno, stalking him round the punchbags and stuff, but right at the end of the session, when he is taking a break, a bit knackered, his mate gave him the bottle of oil to put on his body, and said: "Use this, Frank, you'll be world champion." I liked the moment, not posed at all. He's not even aware of me.'

19 STEVE DAVIS AND BARRY HEARN
35mm: 1600 ASA: 1/60th @ f4.

'Snooker pictures are very difficult. It is almost impossible to take them in the arena: a guy like Davis says "no" as soon as he sees a camera. So it is a question of following them into the press conference afterwards and grabbing what you can. The bonus for me is the cue Davis is still holding. Barry Hearn, his manager, is alongside, listening for the awkward question. I'd be no good at all if I got these two into a studio with a load of props: what I can do is see possibilities as they happen, and snatch them.'

20 DALEY THOMPSON
600mm: 400 ASA: 1/1000th @ f4.

'He is the supreme athlete of my generation. I wanted him statuesque, almost like a classical sculpture. Again it's backlit, and it is always hard to get the exposure right for a black guy. The position lasts about a quarter of a second, and I was pleased to get it. It's grainy – a lot of my work is grainy. It's not something I apologise for. I don't mind graininess at all.'

21 DIVER
35mm: 800 ASA: 1/250th @ f2.8.

'The sport uses a nitrogen burst, to make the surface visible to the diver so he can judge his dive properly, and to create a cushion for him to dive into. Photographically, it is very pretty, but it only lasts a second before breaking up into a load of ugly bubbles. The problem was to get the diver looking as if he was really diving. You don't want him too big. I went up the 30 metre board while he was practising, and leant out. He was diving over my shoulder, as it were. You can't keep on asking these guys to do it again, can you? But he was tremendously helpful.'

22 BOXER: LARRY HOLMES
180mm: 1600 ASA: 1/500th @ f4.

'Larry Holmes was such an impressive boxer. I was pleased with the way this "quick hands" picture worked out.'

23 BOXING: HAGLER V DURAN
600mm: 1600 ASA: 1/500th @ f4.

'I've always had a special admiration for Duran. He's one of the legends. And I always go for the underdog as well, of course. Here he was battling against the odds with Hagler, and at the time I took the picture, he was coming off best. He lost the fight in the end, but the picture says something of what I think about Duran. That was quite a fight – it was a gritty and painful place to be.'

24 ICE HOCKEY
180mm: 800 ASA: 1/250th @ f2.8.

'I find this very amusing. These are ice hockey players at Wembley. Before the match they go into this huddle for a prayer. Good for them; but I can't help being amused by it. I mean, what are they looking for? Has the goalie dropped his contact lens?'

25 JUDO: NEIL ADAMS
180mm: 800 ASA: 1/500th @ f2.8.

'This is another tricky sport – if you don't get it right, it looks like two pillow cases having a fight. Again, I was very careful with the background: the numbers give it some atmosphere, I think. I shot this with a motor drive. I normally use this on single-shot, just as

a winder, so I can keep the camera at my eye. But here I let it go: judo can be over very quickly, and getting an image in which something is actually happening is very tricky. There is the same problem with things like Bruno fights: it can be all over in the first round before you have a shot of the action. You need to cover yourself by taking pictures of him coming into the ring and so on.'

26 SEVE BALLESTEROS
400mm: 400 ASA: 1/1000th @ f8.

'He is another of those people who is a gift to photographers. He is an emotional guy in a sport in which people do not show their emotions much. And to make things even better, he is dark-haired. In golf you are always taking pictures of people against the sky: it is so much easier to make a dark-haired guy look good in such circumstances. I got this at The Open in 1985.'

27 JIMMY CONNORS AND IVAN LENDL
400mm: 400 ASA: 1/1000th @ f5.6.

'Some people always make photographs, and Connors is one of those. You can spend all day photographing a guy like Lendl and have nothing. To get him to show any reaction at all is a bonus, like here. When you're at an event like this, you have your place allocated and that's that. Tommy Hindley, a great tennis photographer, was at the same match, but he couldn't get the shot – the umpire's chair was in the way for him but not for me.'

28 STEVE OVETT AND STEVE CRAM
400mm: 400 ASA: 1/500th @ f4.

'Ovett is a great character. I knew he was struggling, so this was a picture I looked for and got. Cram looks so nonchalant, too. The backlighting was a problem, but it worked for me. In a thing like the Olympics, you don't process the film yourself, it goes straight to London. You have to get the exposure bang on, because no-one will make allowances in the darkroom. You can't exactly bracket the exposures when you have only one chance, either. You learn when to defy the advice of your light metre: that's experience.'

29 SEB COE
400mm: 400 ASA: 1/500th @ f4.

'This is my compensation for missing Coe's finish in Moscow. I went for the line here: I wasn't going to do it again.'

30 GREYHOUND RACING
600mm: 400 ASA: 1/1000th @ f4.

'Dog racing is a really hard sport to take pictures of. Very fast action, very small subject, tricky light, flash forbidden. There was this super dog called Scurlogue Champ, who used to win from the back. It is a hell of a gamble, trying to get the dog to fill the frame: if he'd gone wider I'd have lost him. I was pleased to get such a difficult and unfamiliar sort of shot right.'

31 BOXING GYM: EUSEBIO PEDROZA
35mm: 1600 ASA: 1/125th @ f4.

'I went to take Pedroza at this gym in Carnaby Street, an immaculate place, all shining white paint, no windows. I was working away very happily, knowing I would get something unusual. This group with the medicine ball just came about. I know it looks as if I had faked it, but I swear I haven't. It was just what I saw, and printed up in high key.'

32 FOOTBALLER: DANNY THOMAS
300mm: 1600 ASA: 1/250th @ f2.8.

'This is Danny Thomas of Spurs being chopped down. True, it's a little muzzy about the face, but that doesn't worry me too much.'

33 MARTINA NAVRATILOVA
400mm: 400 ASA: 1/1000th @ f8.

'I like the way she looks so macho in this one, which I took at Wimbledon in 1986. She is strong, and extremely determined. She doesn't look at all like the traditional idea of a lady tennis player. She looks like some one you wouldn't want to meet in a dark alley.'

34 FRANK BRUNO, VICTORY
180mm: 1600 ASA: 1/250th @ f2.8.

'The Bruno fights, on his run-up to his world championship attempt, were all over before they had started. It was really hard to get a shot of him actually in action. It was a nightmare for photographers. You have to get what you can, and I was pleased with this one, of Bruno in triumph.'

35 BARRY McGUIGAN
180mm: 1600 ASA: 1/250th @ f2.8.

'Barry McGuigan liked to get down low, and he was often cautioned for fighting too low. Crouching down was part of his style and here, all you can see of his opponent is a pair of shorts and a leg, and there's Barry's head down there as he is battling away.'

36 BALD GOALIE: JOHN SHAW
300mm: 400 ASA: 1/500th @ f2.8.

'I like the triangle shape as well as the humour. The background was, as usual, the only difficulty. Advertising boards are designed to catch the eye, and in the background of a picture they are really distracting. They are the bane of a sports photographer's life.'

37 SOCCER SCHOOL
300mm: 400 ASA: 1/500th @ f5.6.

'You have to look for pictures all the time. I was here to take a match with the kids at Lilleshall, the football school of excellence. It was for a feature on the place. I took loads of stuff from the match, but this, taken half an hour before anything was supposed to happen, was the one that had the mood of the place.'

38 RUGBY LEAGUE: TAMATI AND HEMSLEY
400mm: 400 ASA: 1/1000th @ f8.

'I love the way you can see, from his expression, that he is getting away from the big guy behind him.'

39 GABRIELLA DORIO
400mm: 400 ASA: 1/1000th @ f4.

'Dorio, another gift to photographers, because of her spirit. I'm pleased with this as a good "finish" shot – it captures the emotion and the joy of winning.'

40 LADIES DAY, ASCOT
500mm mirror lens: 400 ASA: 1/500th @ f8.

'I was working on the group for five or ten minutes when this nattily dressed character, a kind of Beau Brummel figure, with his umbrella, strode across to give the picture something extra, some pace.'

41 BOXER'S HANDS: SYLVESTER MITTEE
180mm: 400 ASA: 1/250th @ f5.6.

'With the light from the window, and the fact that I needed to expose for the opposite side, you have a real problem for the printer. You make a straight print for three-quarters of the area, and then another half-hour to burn the rest in. The printer has done a superb job. I take my hat off to photographers who are masters at printing as well – Amsel Adams, the American land-scape photographer is the best ever.'

42 JIMMY CONNORS
400mm: 400 ASA: 1/1000th @ f8.

'This is another shot that shows how people can make pictures for you. It helps that Connors has dark hair: fair-haired people can get lost in the background. It is hard to get a picture of Becker that really looks like Becker, for exactly that reason. He is a great extrovert personality, marvellous subject, but very hard to get right. I've never seen a definitive shot of Becker. But Connors has always been the answer to a photographer's prayer.'

43 BJORN BORG
400mm: 400 ASA: 1/1000th @ f5.6.

'Borg, the old baseline warrior. An amazing player. I was so pleased to have got the concentration in his eyes: this really is Borg. It was also the first tennis picture taken of a guy *before* the ball gets to him. The technique is quite often used now. I have done the same thing with other players since: but no-one has Borg's concentration.'

44 MARATHON RUNNERS
35mm: 800 ASA: 1/250th @ f4.

'I love the man with the beard and the tights. He looks like superman. It was half an hour before the start, in a way nothing to do with marathon running.'

45 HENLEY ROWERS
400mm: 400 ASA: 1/1000th @ f8.

'Henley is always weird to me: most of the people there aren't interested in the rowing at all. These rowers are out there killing themselves while everybody drinks Pimms. The rowers' exhaustion is the most human part of the whole event, I think.'

46 FEMALE HURDLERS
300mm: 400 ASA: 1/1000th @ f5.6.

'This was at WAAA meeting, and it is a nice combination, I think. It is funny, you could take the same picture in colour, and it wouldn't work. You'd be too busy looking at the colours to see the shapes and patterns.'

47 SHOT-PUTTER: JUDITH OAKES
400mm: 400 ASA: 1/100th @ f8.

'The shot-putt is a great event for Sunday newspaper photographers, because it starts early, and you can get a nice shot away before Saturday afternoon has even got going. This is Judy Oakes, shot with a long lens. The disadvantage of these early shots is that you get bags of empty seats in the background, but I've used such a long lens that they have been taken out of the picture.'

48 IAN BOTHAM
35mm: 400 ASA: 1/60th @ f4.

'Although this is Botham in a non-cricketing pose, I think it still says something about his character. That is an indication of his stature as a sportsman: it would be hard to achieve with many others.'

49 FOOTBALLERS: MARADONA AND STIELIKE
300mm: 1600 ASA: 1/500th @ f2.8.

'I was lucky to catch these two together: two very famous footballers from opposite sides of the world. This double portrait is more my style than the peak-of-the-action stuff.'

50 HEYSEL STADIUM, BRUSSELS
35mm (Autofocus): 400 ASA.

'Some photographers will never take a picture until they have everything just as they want it. Patrick Eagar, the top cricket man, is like that. I'm an emotional photographer, and tend to go off at half-cock. But sometimes that comes off. This is an example, a horrible one, of a snatched picture that came off.'

LANDSCAPES

'The landscapes have got to stand for themselves if they are worth anything. Virtually all of them were taken with a Leica rangefinder camera with a 35mm lens. I used a filter on one or two, no more. As for the pictures: well, they speak for themselves. I hope.'